STORIES FROM THE
White Mountains

Celebrating the Region's Historic Past

Mike Dickerman

Published by The History Press
Charleston, SC 29403
www.historypress.net

Copyright © 2013 by Mike Dickerman
All rights reserved

Back cover: Postcard of English Jack, "Hermit of the White Mountains." *Author's collection.*

First published 2013

Manufactured in the United States

ISBN 978.1.62619.079.5

Library of Congress CIP data applied for.

Notice: The information in this book is true and complete to the best of our knowledge. It is offered without guarantee on the part of the author or The History Press. The author and The History Press disclaim all liability in connection with the use of this book.

All rights reserved. No part of this book may be reproduced or transmitted in any form whatsoever without prior written permission from the publisher except in the case of brief quotations embodied in critical articles and reviews.

Contents

Preface	5
Acknowledgements	7
1. Hiking History of Mount Washington	9
2. Winter Firsts on the Rock Pile	17
3. Exploring the Whites with the AMC	28
4. Moses Sweetser and the Early Guidebooks for White Mountain Trampers	35
5. Fire Towers and Their Pioneering Women Lookouts	48
6. Lumberjacks and Locomotives: The Logging Railroad Era	57
7. Crash of the Triton (and Other Log-Train Mishaps)	73
8. Big Blow: The Hurricane of 1938	79
9. Plane Crash in the Pemi: The Tragic Tale of the Missing Doctors	93
10. A Working Life Spent in the Woods	110
11. Schuyler Dodge and the Mountain View House	116
Bibliography	123
About the Author	127

Preface

While hiking in New Hampshire's White Mountains has long been a favorite pastime of mine, I find almost as much pleasure these days in explorations of a different sort. As I have gotten older, busier and less enamored with the physical stresses of a daylong mountain foray, I have found myself spending more and more time each passing year delving into the rich history of this region.

Just as there are always more mountains to conquer and more backcountry footpaths to seek, there is no lack of subjects to explore when it comes to White Mountains history. As a result, you will find on the following pages a diverse collection of topics that over the past decade or so have, at one time or another, caught my interest and compelled me to look deeper into each subject.

While some of these chapters have previously appeared in print in some way, shape or form—primarily in the pages of the *Littleton Courier* newspaper, of which I have been affiliated with for more than twenty-five years—I have taken the liberty to expand greatly on most of these original pieces. This is especially true of the chapters dealing with logging railroads of the White Mountains, the devastating Hurricane of 1938, the tragic Pemi plane crash in the 1950s that killed two well-known doctors and the story of fire towers and the region's first female fire lookouts. In fact, in some cases, readers probably won't even recognize the original pieces, as I've tripled or even quadrupled their length. In other instances, such as in the final two chapters of this book, I have left the originals pretty much as is, with the exception of some minor grammatical changes and a few factual clarifications.

Preface

Again, like any hike that takes me to a mountaintop for the first time, I have found the journey exhilarating, exhausting and completely satisfying. There have been many bumps along the way, and I've tripped up more than once, but in the end, I got where I was headed, and that's where the satisfaction comes in—bumps and bruises be damned. I hope readers will enjoy the journey as much as I have and that all come away with more knowledge and a deeper appreciation of this beautiful region's fascinating past.

Acknowledgements

As is always the case when I finish a project such as this, there are countless individuals and organizations who aided me along the way. I've tried to the best of my recollection to remember all of you, but in case I've forgotten someone, please accept my sincerest apologies. As many of you know, some of the research for this book was done years ago, and as time has passed by, so has my collective memory of all who were so willing to lend a hand.

First off, I owe a great deal of thanks to the staffs of Littleton Public Library; Weeks Memorial Library in Lancaster, New Hampshire; and the Mount Washington Observatory's Gladys M. Brooks Memorial Library. The folks at each of the facilities were always accommodating and put up frequently with my questions and requests. I'm especially thankful to Dr. Peter Crane, curator of the Observatory library, as he went out of his way at the last minute to confirm information I'd gathered related to stormy weather atop Mount Washington in the 1940s and 1950s.

While many of the photographs appearing on these pages came from my own personal collection of historic images, an equal number were supplied by others such as Dave Govatski, Jeff Leich of the New England Ski Museum and Howie Wemyss of the Mount Washington Auto Road. I also need to acknowledge three individuals who supplied me with a number of superb modern-day images. Without the help of tireless mountain explorers Steve Smith, Chris Whiton and John Compton, this book would have been lacking in such quality images.

Acknowledgements

Although I interviewed the late Schuyler Dodge and Louis Derosia many years ago, their surviving family members went out of their way to supply me with additional information and photographs of their loved ones. Many thanks, therefore, go out to Barbara Dodge, Harold Derosia and Edie Merrill.

I'd also like to thank Iris W. Baird of Lancaster, perhaps New Hampshire's foremost authority on the history of the state's fire towers, for over the years, her enthusiasm for this subject and her willingness to share research data accumulated over several decades has inspired me in countless ways. Likewise, I need to acknowledge longtime local history buff Hank Peterson, for his extensive collection of material related to New Hampshire plane crashes was a great starting point for my chapter on White Mountain plane-related tragedies.

And I again need to thank the great folks at The History Press for helping shepherd this project through from start to finish. Super sales rep Dani McGrath has been in my corner from the start, and her enthusiasm has been unwavering. Meanwhile, expert editorial guidance has been displayed by Jeff Saraceno and Alyssa Pierce, and even though I missed a few deadlines along the way, they have been patient, understanding and exceedingly helpful. I hope I get to work with all of you again sometime in the future.

Finally, I need to thank my wife, Jeanne, who has given up so much of our shared time to allow me to complete this book on deadline and during the busiest time of our year. She has long been my biggest booster and is the one who convinced me twenty years ago to put together my very first book. A dozen books and one million words later, she's still my rock. Thanks for everything you do—completely and forever.

Chapter 1

Hiking History of Mount Washington

As the highest peak in New Hampshire (and all of New England for that matter), it comes as no surprise that the summit of 6,288-foot Mount Washington is the most visited peak in the White Mountains, with more than a quarter-million callers each year. While a good number of those reaching the summit arrive there by mechanical means (via the historic Cog Railway or by automobile), a great number still rely on leg power to ascend through the forested lower slopes of the mountain and up its boulder-strewn rocky cone.

Mount Washington has a reputation like no other in New England, and that certainly accounts for its fascination among locals and visitors alike. From a New England hiker's standpoint, it's a rite of passage to be able to claim "these legs have climbed Mount Washington." Never mind that the mountaintop is cluttered with buildings and, in summer and early fall, hundreds of other humans. It's still a worthy achievement to reach the summit on foot, be it by way of Tuckerman Ravine, Ammonoosuc Ravine or the ancient Crawford Path, which dates back nearly two centuries.

Climbers and explorers, of course, have been hiking up the mountain for more than 370 years now, with Englishman Darby Field laying claim to the first successful ascent back in the early summer of 1642. Field, who was accompanied by two Indian guides during this first ascent, made a second trip to the summit later in the same summer, as did two other ambitious explorers: Thomas Gorges, deputy governor, and Richard Vines, councilor of the Province of Maine. If the primary purpose of these early forays up onto the

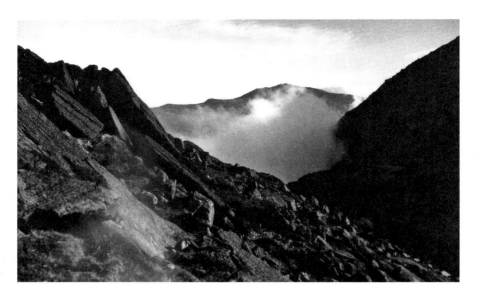

Mount Washington as viewed from the northern Presidential Range near Mount Madison. *Courtesy of Dave Govatski.*

Presidential Range was to discover and recover precious minerals and stones rumored to exist in the mountains, then the trips can only be termed colossal failures, as nothing of great monetary value was ever found.

Considering how remote and inaccessible the mountains were at this primitive stage in American history, it's not surprising that Mount Washington received little attention from explorers for the next 140 years or so. With the exception of one April 1725 ascent, chronicled years later by early New Hampshire historian Jeremy Belknap, few if any published accounts of summit explorations existed up until Reverend Belknap himself took part in an 1784 excursion to the mountain that is considered the first scientific expedition on Mount Washington. The so-called Cutler-Belknap expedition featured probably the first ascent of Tuckerman Ravine and an attempt by trip participants to accurately determine the elevation of the mountaintop. Their guess of "ten thousand feet above the level of the sea" would prove to be grossly inaccurate in subsequent years.

Recreational climbs up Mount Washington did not begin until nearly twenty years into the next century, when Abel and Ethan Allen Crawford, famed settlers of the Bretton Woods–Crawford Notch region, began guiding ascents up the mountain from their respective inns on the west side of the Presidentials. The Crawfords cut the first footpath (today's Crawford Path)

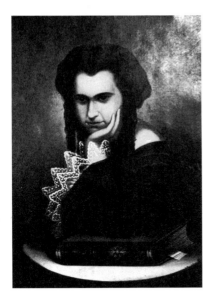

Lizzie Bourne, twenty-three, of Kennebunkport, Maine, succumbed to exhaustion and exposure during an attempted September 14, 1855 climb up Mount Washington. *Mount Washington Observatory Collection.*

up the mountain in 1819 and then added a second walking path two summers later, this one following pretty much the route of today's Cog Railway. Likewise, a footpath up the mountain from the east (Pinkham Notch) was established at about this same time. This route originated in the village of Jackson.

Over time, as transportation improvements made journeys to the White Mountains less of an ordeal and more of an enjoyment, hotels sprang up all over the region, and the increase in tourists resulted in a sharp rise in the number of visitors to the mountaintop. Guidebooks from the mid- to late nineteenth century offered helpful hints on what to expect on any planned ascent of the Presidentials. For instance, the 1867 edition of *Eastman's White Mountain Guide* offered these words of advice:

> *Sometimes the ascent is made on foot, but on account of the unparalleled roughness and steepness of these mountain paths, this method is to most persons too wearisome for enjoyment, unless they spend a long time in the ascent, and pass the night on the mountain. Whatever path or method you select, it is never advisable to attempt the ascent, for the first time, without a guide. Many accidents and inconveniences arise every year from the neglect of this precaution.*

By that time, the mountain had already gained a reputation for being a dangerous place to be at almost any time of the year. Eighteen years earlier, Englishman Frederick Strickland became the mountain's first victim, dying on October 19, 1849, after losing his way in an early fall snowstorm. This was followed six years later by the death of twenty-three-year-old Lizzie Bourne of Kennebunk, Maine, who died of exhaustion and exposure just a few hundred feet from the summit, and in 1856 by the death of seventy-five-year-old Benjamin Chandler of Wilmington, Delaware, also from exhaustion and exposure. In the ensuing 150-plus years, more than 140 others have lost

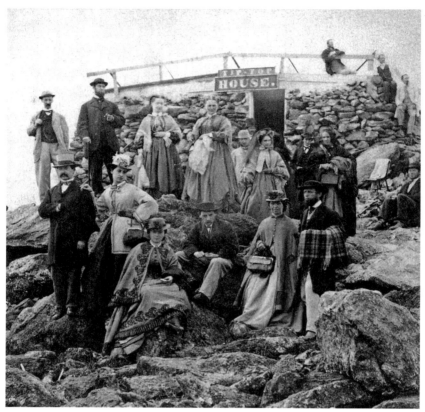

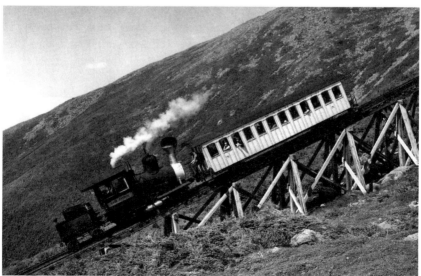

their lives on the Presidentials, some in falls, others in storms and still others in accidents on the Cog Railway or the Auto Road. It's a rare year, indeed, when at least one more name isn't added to the mountain's memorial list.

If the Crawford family can be credited with sparking the first wave of recreational climbing of Mount Washington with the construction of several crude footpaths from the west, then the building of two summit hotels in the early 1850s was the catalyst for turning the mountain into a true tourist destination.

The building of the first Summit House in 1852, and a year later, the Tip-Top House, opened the mountain up to a new breed of adventurous summer explorers. Both mountaintop hostels were immediate successes, with the first Summit House attracting fifty-three visitors on its opening day on July 28, 1852, including a dozen overnight guests, and the Tip-Top House merging with the Summit House in 1854 under the capable management of the Spaulding family of nearby Lancaster.

According to one of the earliest surviving accounts by a visitor to the Tip-House House, "It was then believed that no person could stand the 'rarified air' of the summit unless he indulged in frequent libations. The Tip-Tip House, with its flat roof, was hardly complete, but as you stepped in just beside the door stood the affable bartender, backed by various decanters, from which he dispensed at once to all new comers the health-giving elixir that was considered more necessary than food even."

Within two decades of the opening of these mountaintop retreats, Mount Washington's heights were made even more accessible to the general public as a long-planned carriage road to the summit from the east was finally completed in 1861. It was followed eight years later by the completion of the $140,000 Cog Railway, the brainchild of Littleton businessman and New Hampshire native Sylvester Marsh.

At the same time, writers like Reverend Thomas Starr King were popularizing the mountain with their descriptive accounts of visits to the Mount Washington and the White Mountains. In his widely read book *The White Hills: Their Legends, Landscape and Poetry*, one of the true classics in White Mountain literary annals, Starr King wrote:

Opposite, top: Guests pose for a group shot in front of the Tip-Top House at the summit of Mount Washington. The stone structure was built in 1853. *Author's collection.*

Opposite, bottom: A Cog Railway engine and passenger car make their way over Jacob's Ladder, high on the western slope of Mount Washington. The mountain-climbing train first began operations in 1869. *Author's collection.*

The first effect of standing on the summit of Mount Washington is a bewildering of the senses at the extent and lawlessness of the spectacle. It is as though we were looking upon a chaos. The land is tossed into a tempest. But in a few minutes, we become accustomed to this and begin to feel the joy of turning round and sweeping a horizon line that in parts is drawn outside of New England.

While the mountain was frequented often in summer, winter visits to its top were rare or unheard of. The first winter ascent took place in December 1858, when a deputy sheriff from Lancaster, Lucius Hartshorn, was called upon to "make an attachment" on the summit property in connection with ongoing litigation involving his father-in-law Samuel F. Spaulding. Hartshorn was accompanied up the mountain by well-known guide Benjamin Osgood of the Glen House in Pinkham Notch. Three winters later, in February 1862, John Spaulding of Lancaster, along with two others, were the first to spend a winter night on top the mountain. They stayed two days and nights in the ice-encrusted Summit House—mainly because a snowstorm had moved in, preventing a safe descent—and returned with remarkable stories and photographs. (The first long-term winter occupation of the mountain occurred in 1870–71, with four members of a scientific team living in the newly built summit depot owned by the Cog Railway. The trials and tribulations of these intrepid adventurers are chronicled in detail in the book *Mt. Washington in Winter*, published in 1871.)

As interest in the mountain grew, and as the grand hotel era ushered in waves of summer visitors to the White Mountains, the trail network on the Presidential Range grew accordingly, with members of the recently formed Appalachian Mountain Club (AMC) playing a huge role in the development of these new footpaths. Among the new trails built were the Raymond Path (1879) from the carriage road to the famous snow arch in Tuckerman Ravine; the Tuckerman Ravine Trail from the snow arch to the summit (1881), the Great Gulf trail to remote Spaulding Lake (also 1881); the Gulfside Trail, connecting the Northern peaks with Mount Washington (mid-1890s); the Boott Spur Trail from Hermit Lake (1900); and the Glen Boulder Trail to the summit (1906). Winter explorations of the Presidentials were also on the rise during this time period, with first ascents of the Tuckerman Ravine headwall, the Huntington Ravine and the Great Gulf all taking place between 1895 and 1905.

Further enticing the growing number of hikers to visit the mountain was the AMC's decision to build and open a new mountain hut near the two

Celebrating the Region's Historic Past

Stage drivers on the Mount Washington Carriage Road gather at the base of the mountain near the historic Glen House. *Courtesy of Howie Wemyss, Mount Washington Auto Road.*

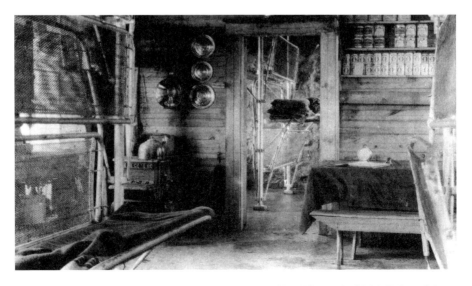

An early postcard image of the interior of the Appalachian Mountain Club's Lakes of the Clouds hut. *Author's collection.*

Lakes of the Clouds on Mount Washington's southwest flank. This stone hut, which has been enlarged several times over the years and is the largest of the AMC's eight backcountry huts in the White Mountains, opened for summer use in 1915. That same year, a new Summit House hotel was also opened atop the mountain, the successor to the second Summit House destroyed by a devastating fire seven years earlier. Ironically, just a week after the grand opening celebration of the new Summit House, the old Tip-Tip House was gutted by fire.

As the years wore on, more trails and more milestones were established on the mountain. Among these were: construction of the Lion Head Trail and the establishment of AMC's Pinkham Notch Camp in 1920; the first sled dog ascent of the mountain by Arthur T. Walden in 1926; the first ice-climbing expeditions into Huntington Ravine (1928–30); the winter reoccupation of the summit by the fledgling Mount Washington Observatory (1932–33); and the world-record land wind speed of 231 mph, measured atop the mountain on April 12, 1934. Other notable events on the mountain included the establishment of the Jewell Trail up the west ridge of Mount Clay in 1934, with much of the work done by the Civilian Conservation Corps, and the building of a new trail up the long east ridge of Boott Spur in 1952.

With it storied past, its notoriety for having some of the worst weather in the world and its "fatal attraction" (as evidenced by the overwhelming success of Nicholas Howe's book *Not Without Peril)*, Mount Washington remains one of the state's major tourist attractions, drawing well over a quarter-million visitors to its summit every summer and fall. Of those, nearly a third reach the summit via the mountain's busy trail network. These paths serve as more than convenient routes to the summit, however. They also serve as important links to Mount Washington's remarkable and fascinating heritage.

Chapter 2

Winter Firsts on the Rock Pile

A few years back, a research project found me making regular trips to North Conway and the Mount Washington Observatory's Gladys Brooks Memorial Library, where I devoured with delight the pages of *Among the Clouds*, the former tourist newspaper that for years (1877–1908) was published atop Mount Washington.

For the most part, my research at the time was centered on the trails that existed in the mountains during the years that the paper was published or on published accounts of mountain explorations in the vicinity of Mount Washington and the Presidential Range. Since practically every issue of the paper included mention of hiking parties that had visited the summit, there was certainly no shortage of material to sift through. Some pieces were more interesting or unusual than others, however, and those are the ones I've tended to focus on the most.

A good example of one gem that I came across was an article that first appeared in the September 9, 1903 edition of the paper. Titled "The First Ascent By Women in Winter," the article looked back at the first successful winter ascent of Mount Washington by female climbers.

The article, whose authorship is unknown, describes events surrounding the winter 1874 ascent of the mountain by four members of the pioneering Crawford family, including three children of famed trail builder and innkeeper Ethan Allen Crawford. According to the account, the Crawfords made the climb from the western side of the mountain, following the Cog Railway tracks from the base station right to the summit.

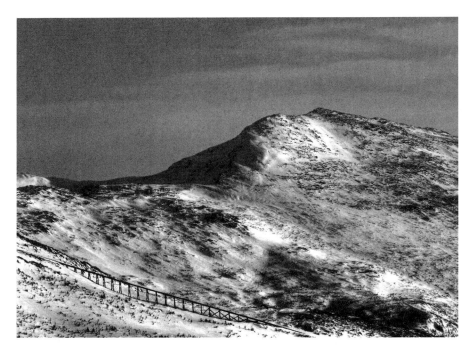

The Crawford women followed the course of the Cog Railway tracks during their historic 1874 winter climb to the summit of Mount Washington. Seen here rearing up behind the trestlework is Mount Monroe. *Photo by Chris Whiton.*

The hiking party consisted of Mrs. E.P. Freeman of Lancaster and Mrs. Charles Durgin of Andover (both daughters of Ethan Allen Crawford), plus their brother, William H. Crawford, of Jefferson and a teenage nephew, E. A. Crawford III. The latter was staying at the Cog Railway base station with his father, Ethan Allen Crawford II, employed at the time by the Cog to help get out "the next summer's supply of wood." It was during a visit to the Cog base area by the sisters and William Crawford when the impromptu ascent took place.

"The day was fine and not very cold, and at one o'clock, the ladies, with William A. Crawford and young Allen Crawford, set out for a walk along the railway," reads the article, which is based on Mrs. Freeman's recollection of the event. She was in her early eighties at the time, "but tells the story...with the enthusiasm of a girl describing her first mountain climb," said the paper. As an aside, it should be noted that Mrs. Freeman's husband, Orville, was a civil engineer who helped survey the route of the Cog Railway line back in the mid- to late 1860s.

"Mrs. Freeman, in telling the story, says that they had no definite idea of getting to the top, but so easy did they find the walking that they kept on, and at four o'clock, they reached the Summit. The ladies had no more wraps, she said, than they would have worn to church on that winter's day."

The nephew, E.A. Crawford III, also told the paper that the winter of 1873–74 had been a mild one on the mountain, making the ascent possible. "We should not have thought of going up except that I had already been up several times during that winter and was sure we should have no trouble," said Crawford. "After we got above timber line, there was a crust that would hold a horse anywhere, and we could walk on it without slipping. The track was visible all the way, but the crust was much easier to walk on. I have made a great many trips up Mount Washington, but I think that was the easiest. We had no ice creepers, but got along perfectly well."

After reaching the summit, the Crawfords stayed the night in the U.S. Signal Service office, where three staffers were admittedly surprised to see that the two women had safely reached the mountaintop. "The ladies had a most hospitable welcome, two of the officers giving up their room to them for the night, and everybody made comfortable in the cozy quarters," reported the paper.

The following day, under clear skies, the Crawfords safely made their way back down the mountain, and "the ladies reached home to surprise their friends with the story of their unprecedented journey."

In further researching this relatively unheralded but historic event, F. Allen Burt states in his 1960 book, *The Story of Mount Washington*, that the climb took place on February 24, 1874, and that Sergeant William Line was the officer in charge at the summit signal station. Also atop the mountain that day were Signal Service officers Thornett and DeRosher. Burt goes on to write that while temperatures were mild when the Crawfords began their unplanned ascent, "the temperature fell on the way up, and when they reached the summit…the thermometer stood at 8 [degrees] below zero, with the wind at fifty miles an hour." (In the *Among the Clouds* account, the summit winds were estimated at thirty miles per hour, and the summit temperature was reported to be two degrees below zero.)

Frederick W. Kilbourne, in his classic history *Chronicles of the White Mountains*, published in 1916, interestingly sets the date of the ascent as January 1874, not February, and adds that Mrs. Freeman "described the trip as 'glorious' and expressed the hope that all her women friends might enjoy the pleasure of making it in winter." (Moses F. Sweetser, author of a popular hiking and tourists' guide to the White Mountains in the late

Summit buildings atop Mount Washington are encased in rime ice in this undated winter image. *Author's collection.*

1800s, also gives the month of the ascent as January 1874, while a 1966 edition of Lucy Crawford's *History of the White Mountains* uses the February 24, 1874 date.)

Both Burt's and Kilbourne's books *are* in agreement on one other important factual item, however. They concur that no further winter climbs of the mountain were made by any other woman until February 1902, when Dr. Mary R. Lakeman of Salem, Massachusetts, joined a group of Appalachian Mountain Club members in an ascent of the mountain via the carriage road

on the Pinkham Notch side of Mount Washington. Thus for nearly thirty years, the Crawford women could lay claim to being the only ladies ever to stand atop the Rock Pile in winter.

Tragedy on the Summit Snowfields

As the Crawford women probably would have attested, winter on Mount Washington is truly something special, but the challenges presented by the mountain's fabled weather and its often-notorious conditions frequently spell danger for its off-season visitors. As the two following tales reveal, whether one is challenging the mountain on foot or skis, the consequences of an unintended slip or poor decision-making can be fatal.

Since the mid-1930s, when skiing really took off as a popular winter sport in northern New England, Mount Washington and the Presidentials have been the scene of more than a dozen fatal ski-related incidents. Predictably, many of these accidents have taken place in Tuckerman Ravine, the well-known glacial cirque that attracts more skiers than any other locale on the Presidentials. A surprising number have occurred elsewhere, however, including that of Mount Washington's very first ski-related victim, nineteen-year-old John Winthrop Fowler of New York, New York, who perished on the mountain on April 1, 1936.

According to Wendell Lees's account in the June 1936 issue of *Appalachia*, the respected journal of the Appalachian Mountain Club, Fowler and a companion, McKim Daingerfield, had climbed to the summit of Mount Washington and were hoping to find skiable terrain on the mountain's steep summit cone. However, the higher up the mountain they went, the worse the snow became, so after abandoning plans to ski the summit snowfields, they continued on foot up to the mountaintop and sought brief refuge in the former summit building known as Camden Cottage.

At approximately 3:30 p.m., Fowler and Daingerfield decided to leave the summit and begin hiking down off the mountain, skis in hand. Because they experienced some difficulty in securing the door to Camden Cottage, Daingerfield lingered on the summit to make sure the door was latched shut properly while Fowler headed off by himself, presumably in the direction of Tuckerman Ravine, from whence the pair had ascended earlier in the day. Within minutes, but unbeknownst to one another, both Fowler and

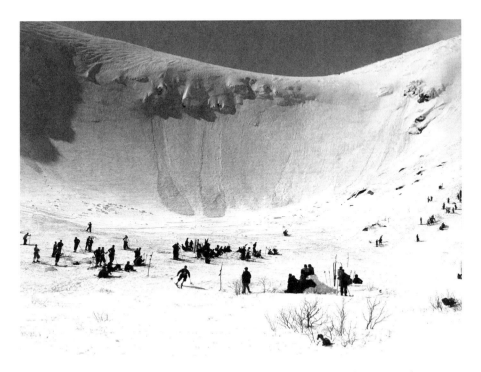

Tuckerman Ravine and the upper slopes of Mount Washington have been attracting adventurous skiers such as John Fowler and McKim Daingerfield for nearly a century. *New England Ski Museum Collection.*

Daingerfield would find themselves sliding uncontrollably down the summit cone on the hard-packed, icy snowfields. Daingerfield would survive his hair-raising tumble, while Fowler would not.

Lees reported that Daingerfield fell an underdetermined distance down the summit cone before being halted by several rocks. Groggy but alert enough to continue onward, Daingerfield methodically made his way off the mountain and down to AMC's Pinkham Notch Camp at the base of the mountain, which he reached at around 7:30 p.m. Once there, he burst into the camp "asking wildly" for any news of his skiing partner, Fowler, who he had not seen since becoming separated from him back at the summit.

After it was determined that Fowler had not come down off the mountain via a different route (i.e. the Auto Road and Glen House site), AMC hutmaster Joe Dodge set into motion a rapid-response search effort, enlisting the aid of several Mount Washington Observatory staffers

(including Lees) to comb the upper reaches of the mountain. Searching by flashlight in agreeable twelve-degree weather, the observers decided to concentrate their initial efforts on the southwest slope of the cone, which would have been the likeliest descent route if Fowler had intended to strike off for Tuckerman Ravine. As Lees noted, this would also have been the most likely place for Fowler to have slipped and fallen, just as his partner had. "The slope starts about one hundred yards from the summit and extends, unbroken, except for scattered rocks, down to the Alpine Garden," wrote Lees. "The angle is very steep, reaching a maximum near the bottom of an estimated 45–50 degrees."

Barely two hundred yards down from the summit, the searchers first came about faint tracks made in the boilerplate snow. The tracks, Lees said, were "obviously made by the sides of boots kicked in hard." These tracks continued only another one hundred feet or so and were replaced by two "parallel furrows," indicating that whoever had made the foot tracks above had lost his balance and slid down the cone. The trail now led directly to several large rocks halfway down the slope, and atop one of them could be seen a glove and ski pole. Blood could also be seen in the snow just below the rock. The rocks were about nine hundred feet below the spot where the boot tracks had ended.

Within minutes, the searchers came across Fowler's badly beaten body, and though he was still breathing, it was obvious he'd sustained serious injuries, as his head was badly cut, his feet and hands frozen and he'd not moved an inch after stopping his slide. Despite heroic efforts by Observatory staffers Jean Marsh and Bill Lingley, who tried for more than an hour to revive Fowler while Lees hiked back to the summit to radio for extra assistance, there was really no hope that the skier would survive. By the time Lees returned to the accident scene shortly after 10:00 p.m., Fowler had ceased breathing, no pulse could be detected and he'd unknowingly become the mountain's first ski-related fatality.

Interestingly, the death of John Fowler back in 1936 bears striking similarities to the March 7, 2004 death of thirty-nine-year-old skier Rob Douglas of Verhsire, Vermont, who fell an estimated one thousand feet down an icy snowfield high up on the Great Gulf headwall below the summit of Mount Clay. In both instances, poor snow conditions forced the victims to abandon planned ski descents of the mountain, and in each case, one other member of their respective ski parties also fell, but neither sustained fatal injuries.

> Just six weeks after Fowler's death near the summit of Mount Washington, Grace Sturgess, twenty-four, of Williamstown, Massachusetts, became the mountain's second ski-related victim. While skiing in Tuckerman Ravine on May 15, 1936, a large block of ice, five or six feet in diameter, broke off from the rocks high up in the center of the Ravine, slid down the steep headwall and struck her "squarely on the left side" as she inadvertently skied directly into its path.

Mountain's First Winter Victims Weren't Up to the Task

While researching the story behind Mount Washington's first ski-related death, I also stumbled across an interesting account of another landmark Presidential Range tragedy that took place four years before the unfortunate death of John Fowler. This incident involved three Massachusetts climbers who were attempting a winter ascent of the Rock Pile.

The date was January 31, 1932, and at the western base of Mount Washington, at the Cog Railway base station, Ernest Wentworth McAdams, twenty-two, of Stoneham; Joseph Benjamin Chadwick, twenty-two, of Woburn; and Donald Higgins, twenty-four, of Winchester, were gung ho to spend the next two days atop the Northeast's most famous peak.

The trio had arrived at the Cog Railway base area the day before, taking full advantage of what had been, at least up to that point, a mild January. With temperatures the previous couple days climbing well into the thirties, and with little snow on the ground, they were able to drive their Ford the length of the Base Road. Once at the Cog, they spent much of the evening conversing with the Cog's winter caretakers (Mrs. and Mrs. Charles Buckner) before settling in for the night at their makeshift campsite next to their parked car.

As morning dawned on the thirty-first, light overnight snow flurries had ended, and breaks in the cloud cover seemed to portend decent weather conditions during the coming day. Never mind that it was just five degrees when the hikers began their trek up the mountain—or that the three were

Celebrating the Region's Historic Past

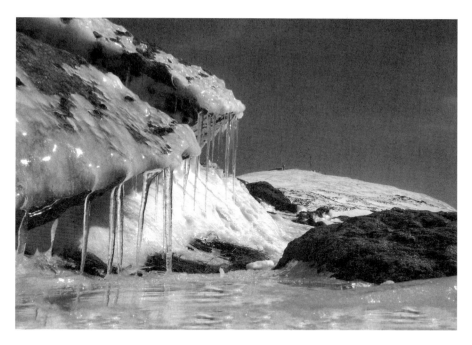

Ice and snow often make for treacherous conditions on Mount Washington, where more than 140 people have lost their lives over the past 165 years. *Photo by Chris Whiton.*

only marginally equipped with enough gear to contend with the mountain's often brutal winter conditions. Packed onto their makeshift sled skis, which were used to more easily haul their gear up the mountain, were "two blankets and a waterproof apiece," recalled Higgins in an article in the June 1932 edition of *Appalachia*. Wrapped inside the bundles were their food supplies for a planned two-night stay at the summit. As for clothing, they carried with them short leather coats, heavy sweaters and flannel shirts. They all wore stocking caps, while two of the three were outfitted with mittens (the other wore gloves). They also wore cotton breeches, heavy woolen socks and overshoes. Only Higgins, however, thought to wear his long underwear.

The hikers' planned ascent route was by way of the Cog Railway train tracks, and for the first hour, almost all spent below tree line, few if any problems were encountered. It wasn't until the climbers had passed by Jacob Ladder's—the steep trestle high up on the mountain—that troubles began to surface. First, a light snow began to fall, then the wind suddenly picked up in intensity. At first, this helped push the climbers up the tracks, as the wind was at their backs, but soon the numbing effect of the wind,

coupled with temperatures that were now approaching ten degrees below zero, began taking its toll on the hikers. When Chadwick, the one hiker in the group wearing gloves, complained of a cold left hand, Higgins offered to exchange his left-hand mitten for one of Chadwick's gloves. But shortly after making the exchange, Higgins lost the glove in the wind and continued up the mountain with one hand exposed to the elements.

As the hikers neared the Gulf Tanks, barely a half mile from the summit, they were confident of completing their ascent. But as the Cog tracks curved to the south and exposed them to what was now a harsh crosswind, progress slowed to a literal crawl as the three men took to their knees. Within minutes, two of their ski-sled packs had been blown off the tracks, and then MacAdam was tossed off the tracks. The packs were left to the elements, as was MacAdam, who would not and could not go any farther.

Soon thereafter, Chadwick also gave in to exhaustion, while Higgins struggled on, even though he was blown from the tracks on two different occasions. Sometime around noon, Higgins finally reached the summit and was able to seek refuge in the mountaintop Camden Cottage, where he was somehow able to start a fire, even with a frostbitten left hand and "glazed" eyes.

For the next forty-eight hours, Higgins holed up inside the relatively comfortable summit structure, where he was able to find some modest food provisions (eggs, bacon, flour and tea). After one aborted attempt to flee the summit on Monday, February 1, Higgins did manage to make his way back down the mountain the following day, this despite a severely swollen hand and serious vision limitations. When he arrived at the Cog Railway base station, he immediately sought help from the winter caretakers, the Buckners, who rendered first aid to Higgins and notified authorities of the unfolding tragedy on the mountain.

However, it wasn't until Wednesday, February 3, that a search team was able to get up the mountain to look for MacAdam and Chadwick, both of whom were presumed to be dead. MacAdam's body was found first, lying underneath the railway tracks approximately 823 feet from the summit and Camden Cottage. A few hours later, after obtaining more information from a handwritten note Higgins left inside Camden Cottage prior to his departure the previous day, Chadwick's body was found, also lying near the Cog tracks. He was a mere 418 feet from the summit, or less than one-tenth of a mile from the safe refuge.

In the final analysis, it was concluded that the hikers were simply unprepared for the kind of weather they encountered on the mountain.

"In the matter of equipment, it may be said that the climbers were attired in moderately sensible clothing which would have proven adequate for the average winter weather, but it is for the unexpected and unusual weather that the White Mountain climber should prepare himself," wrote Robert Scott Monahan in his *Appalachia* report concerning the twin deaths. "They did not possess any of the special winter mountain gear which the serious winter mountain climber wears. The use of parkas, woolen helmets, and creepers might have been the determining factor between success and disaster." Monahan added that the failure of the two victims to wear long underwear, choosing instead to wear short cotton pants, might have been their "greatest" error.

"The tale is essentially one of a party's attempting a climb to which they were in every way—in training, equipment, experience, and morale—inadequate," concluded *Appalachia* editor Robert Underhill. "They did nothing egregiously wrong; they simply failed to understand the problem they were facing and possible eventualities."

In this instance, the eventuality was death, and for the first time ever, Mount Washington had taken the lives of two ambitious but ill-prepared winter hikers.

Chapter 3

Exploring the Whites with the AMC

One of the best resources for accounts of early hiking explorations in New Hampshire's White Mountains is *Appalachia*, the long-published semiannual journal of the Appalachian Mountain Club. Starting with the very first issue of *Appalachia*, which appeared in June 1876—just months after AMC came into existence—these invaluable accounts of pioneering adventures became staples of the journal, and in many of the early issues, it was not uncommon to find a half dozen or so trip reports by club members. As very few trails existed in the Whites prior to the 1880s, many of these adventures were strictly bushwhack efforts over terrain seldom before visited by humans. A sampling of places visited by these intrepid White Mountains explorers included the interior of the Pemigewasset Wilderness, the heights of Garfield Ridge and the remote summits of the Wild River valley on the Maine–New Hampshire border.

Over the years, I've read and re-read many of these accounts and naturally have my favorites among the dozens that appeared in print between 1876 and 1890. Following are a few of those.

From the March 1877 issue: On August 29, 1876, William H. Pickering and a friend climb Mounts Webster and Jackson in the southern Presidentials. Beginning from the top of Crawford Notch, they make their ascent of the ridge via Silver Cascade and then bushwhack between the two summits. Of Mount Webster, Pickering writes, "The slope on the side of the Notch is remarkably steep and affords fine opportunity for rolling boulders." As for the ridge walk between the two summits, Pickering notes, "The walking was

quite easy and level through tall evergreens, neither summit being visible any of the way."

He goes on to describe the summit of Jackson thusly: "The summit consists of a little cone or nearly bare rock, about 100 metres (or yards) in diameter at the base, and nearly 25 metres or 80 feet in height. Only a few low bushes and some scanty grass grow upon it, and it has altogether a most lonely appearance."

A day later, Pickering and his hiking companion climb to Mounts Crawford, Resolution and Giant's Stairs by way of the old Davis Path, which by that time is a little-used approach trail to Mount Washington. Noting the condition of the trail between Crawford and Resolution, Pickering writes, "The old Davis Path can be followed part of the way, but it is easier to force one's way through the bushes than to spend time tracing it."

From the July 1880 issue: Club member Webster Wells and three companions traverse the rugged landscape connecting Mounts Hancock, Carrigain, Lowell and Anderson in the central White Mountains. Today, as then, a venture such as this is completely off trail and is rarely attempted. Wells's multi-day trek begins on August 27, 1879, at Greeley's in Waterville, and on the first day, the party reaches the base of Mount Hancock. On the second day, the adventurers ascend the mountain, enjoying a lengthy stay atop North Hancock. They then follow Hancock's curving ridgecrest to the ridgeline connecting it with Carrigain, the most centrally located of the region's high peaks.

Along the way from Hancock to Carrigain, Webster and company climb up and over a peak commonly known today as "The Captain," from which they spot hidden Carrigain Pond, a secluded four-acre pond situated just northeast of The Captain. "We reached it without difficulty," writes Wells. "Its sandy beaches were completely covered with deer tracks, some of which our men said had been made within an hour. No traces of axe-marks or fires could be found in the vicinity, and it is doubtful if any human beings have ever before visited the locality."

After spending ninety minutes there, the explorers continue on up to Carrigain's summit and then descend the "Club path" up Carrigain from Livermore before camping out near Carrigain Brook. The next day includes ascents of trail-less Mount Anderson and Lowell and a visit to Carrigain Notch. The group returned to Waterville on the fourth day.

From the April 1883 issue: Augustus E. Scott writes an extensive and detailed account of what is later known as the Scott-Ricker expedition of the Twin-Bond Range. This purpose of the trip is to determine whether it is

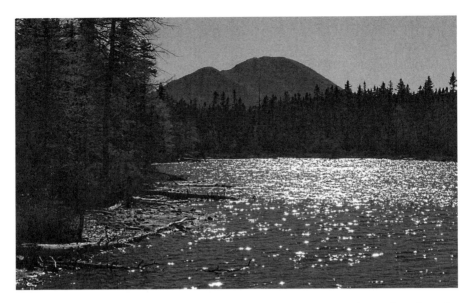

The familiar profile of Mount Carrigain, deep in the Pemi Wilderness, is seen here from the shore of remote Shoal Pond. *Photo by John Compton.*

feasible to place a trail over this hard-to-reach mountain range in the interior Pemigewasset wilderness.

The August 1882 trip includes a visit to the summit of 4,698-foot Mount Bond, which at that point is actually an unnamed peak. Of Mount Bond's view, Scott writes, "We had felt the views from South Twin and from the plateaus of [Mount] Guyot were grand and beautiful, but the view from this crag surpasses everything we have ever beheld. Never before have we realized the extent of the Pemigewasset Forest or the grandeur of the mountains which rise in and around it."

From the summit of Mount Bond, Scott's group, which includes journalist Charlotte Ricker, bushwhack down to the East Branch of the Pemi and North Fork Junction and then follow the river to Thoreau Falls, their "old guide" (Allen Thompson of Bethlehem) catching hundreds of trout along the way. From there, the main body of trampers bushwhack up and over the Field-Willey Range while a totally exhausted Ricker and two men hike out of the wilderness by way of Ethan Pond (called Willey Pond back then).

Another trip into the Pemi, also in the summer of 1882, sees Randall Spaulding and a friend hike from Crawford Notch to Franconia Notch. After first climbing Mount Willey in hopes of getting their bearings and taking a

Celebrating the Region's Historic Past

The plateau of Mount Guyot's exposed ridgeline offers a "grand and beautiful" view of the surrounding mountains, proclaimed Augustus Scott. *Photo by John Compton.*

The peaks and ridges of the Twin-Bond Range provide a dramatic backdrop for this shoreline view from seldom-visited Bear Pond. *Photo by Chris Whiton.*

good aerial view of the country they plan to explore, the men descend off the back side of Willey by way of a stream that A.E. Scott and company had used to ascend the Field-Willey Range during their Pemi adventure. "The broken stumps and pointed evergreens that stand against the sky, and the long channel of white rock down which the stream slides so easily and musically, make a picture I cannot forget," writes Spaulding. "Two such spots of picturesque beauty as this, and Thoreau Falls should in some way be made accessible to summer tourists."

From the December 1883 edition: Eugene Beauharnais Cook of Hoboken, New Jersey, the well-known summertime resident of Randolph and tireless trail builder and mountain explorer, reports on his July 23, 1883 reconnaissance of little-visited Mount Hale in the Little River Range near Bethlehem and Twin Mountain. Traveling solo, Cook departs from the Twin Mountain House at 8:30 a.m. and enters the woods, where extensive logging activity has been taking place. "There is an awe connected with the idea of primeval woods, but there is something much more awful about prime-evil logging roads!" declares Cook.

Cook follows a series of logging roads and then heads generally south, climbing a subsidiary peak (approximate elevation 3,157 feet—perhaps South Sugarloaf or a spur to the northwest of the summit). He reaches the north summit of Hale shortly after 2:00 p.m. and then the main summit at 3:00 p.m. "The top of Mt. Hale is wooded; but on both its highest heads there are bald spots amid the tree growth, where the gales of winter seem to have disposed of trees of too lofty aspirations," writes Cook. He adds, "The 'Little River Mountains' do not seem to possess sufficient individuality to be so called, but appear, from the top of Hale, rather as a gently scalloped ridge connecting Mt. Hale with Mt. Thompson and the Twin Range."

He estimates the elevation of Hale's highest summit to be 4,198 feet.

Another Cook account appearing in the December 1883 edition of *Appalachia* (but actually covering a trip he took five years earlier in 1878) describes one of the earliest recorded ascents of Mount Garfield, or, as it was known then, Mount Haystack. In this late August expedition, Cook and five others—Reverend H.G. Spaulding, Professor E.P. Gould, Ellis Seymour, Harry Cumner and "young" Harry Wadleigh—start from the Goodnow House in Sugar Hill and first ascend Mount Lafayette, presumably via the Greenleaf Path. After reaching Lafayette's summit shortly before noon, the group follows the ridgeline north and east toward Garfield, losing sight of Garfield's peak once below tree line. The group reaches Haystack Lake (Garfield Pond) at 4:05 after an estimated three-mile bushwhack, and despite

Pyramid-shaped Mount Garfield, long a favorite all-season destination of White Mountain hikers, is framed here by snow-laden trees. *Photo by Chris Whiton.*

Cook's desire to continue on to the summit of Haystack, it is decided it would be better to establish a camp for the night along the branch of the Gale River that flows from the lake. Surprisingly, as the group is making camp, three Bethlehem "pedestrians" bound for the East Branch of the Pemi emerge from the woods and made quick acquaintance with Cook and his fellow trampers. They, too, opt to make camp for the night along the same brook, and the two parties enjoy the evening hours relaxing around their campfires, mapping out a route for the fishermen, drinking coffee and trading tales.

After the two parties bid each other farewell the next morning, Cook's party makes quick work of its ascent of Garfield, climbing the steep half mile or so in just thirty-three minutes. Along the way, Cook writes, "We soon came upon evident traces of previous visitors," and once they reach the summit, he notes, "A pile of rocks, surmounted by a staff, greeted our sight."

After a considerable stay at the summit, the Cook party retraces its steps back to Haystack Lake and then proceeds "down the east side of the branch

of the Gale River…being careful to keep near enough to follow the course of the stream, and far enough away to secure good traveling ground." They eventually reach a good woods road that leads them to a bridge over the Gale River near the "venerable" sawmill at the so-called Gale River settlement, some four-plus miles distant from the summit. From there, they follow the old Gale River Road to the Bethlehem–Franconia road.

Another early ascent of Mount Garfield, this from the summer of 1885, appears in a later edition of *Appalachia* (March 1886) and is penned by AMC member Gaetano Lanza. Joined by Robert Candler and G. Herbert Potter (Brooklyn), Lanza ascends Garfield from the north on a planned two-day trip that also includes an ascent of Mount Lafayette. The trio start from Goodnow's in Sugar Hill and then take the Bethlehem road from Franconia and a logging road leading to the Gale River Mills. From the mills, they cross the railroad bridge over the Gale River and then take a course that initially follows the river. "We found a large number of logging roads running in all directions, all of them in poor condition, very wet and more or less obstructed by fallen trees," writes Lanza. After reaching the Gale River forks, they take the right-hand fork, proceed along a fisherman's trail and then come to another fork about four and a half miles upstream from the railroad bridge. Here they choose the left-hand fork and follow "the largest branch, whenever any more forks were reached." The last branch they take eventually peters out, and they soon find themselves "approaching the summit by a very direct course." They finally reach the top at 5:00 p.m.

In describing their ascent route, Lanza recalls, "After passing the forks, we were troubled by the presence of a great deal of young growth, together with much fallen timber, through which it is impossible to proceed rapidly. Near the top is also a wide belt of pine scrub. Nonetheless, taken as a whole, the character of the travelling is not as bad as in several other places in the mountains."

Like Cook's party in 1878, the group spends the night at Haystack Lake before striking off for Lafayette the following morning, following the connecting ridge that would remain trail-less until the second decade of the 1900s.

"The view of the wilderness back of Garfield, and the beauty of the immense mass of mountains to the south as they can be seen only from this point, fully repaid us for our labor," writes Lanza. "The summit itself is formed of very few large rocks, presenting a perfectly flat surface on top, the mountain being entirely wooded with this exception, the part that is free from trees being not more than seventy square feet."

Chapter 4

Moses Sweetser and the Early Guidebooks for White Mountain Trampers

Guidebooks are an essential resource for any tramper, regardless of age, experience or expertise. But no one finds them more useful than the hiking enthusiast who's just starting out. When I first took up hiking three decades ago, I had one or maybe two trail ventures under my belt when I decided to purchase my first copy of the venerable *AMC White Mountain Guide*. Up to that point, I'd relied solely on the "expertise" of my fellow hiking companions, who admittedly had little or no real on-trail experience. Since we were basically hiking just trails that my companions had traversed once or twice before with some of their older siblings, it was obvious right away that if I was really going to get serious about climbing more of New Hampshire's majestic mountains, I'd need something a whole lot more comprehensive.

As any visit to your local bookstore will attest, today's hikers have a slew of guidebooks to choose from, though none rival the AMC guide for thoroughness and accuracy. There are hiking guides for "regular" folks, guides for families, guides for backpackers and guides for "senior" hikers. There are also guides for dogs and guides designed strictly for "peakbaggers." The list goes on and on and on.

Given the guidebook choices we have available to us today, it's hard to comprehend that there was once a time when persons interested in exploring the White Mountains did not have the luxury of choosing between a dozen or more hiking guides. In fact, it wasn't until just about the time that the Appalachian Mountain Club was being formed, in 1876, that the first serious guide for White Mountains trampers was published. It was during

that same year that *Osgood's White Mountains: A Handbook for Travelers* by Moses Foster Sweetser debuted and quickly became the authoritative guide to anyone seriously contemplating mountain excursions.

Sweetser's guide, which went through a dozen or so different editions between 1876 and 1895 (and several name changes as well), covered every area of the region, and even though many mountains were trail-less at the time, the author made it a point to make mention of just about every major geographical feature in the Whites, even if it wasn't yet readily accessible by foot.

A good example of this is contained in the first edition's section on the Franconia Notch region, where there are pages of handy information on everything from the trails up Mount Lafayette to a certain infamous rock profile high up on the eastern slopes of Cannon or Profile Mountain. The Franconia Notch section also lists accommodations in the immediate vicinity (namely the original Profile House and Flume House) and gives passing mention to scenic places such as Echo Lake, Profile Lake and Moran Lake (now known as Lonesome Lake).

But there's also a listing for the Haystack, described by Sweetser as a "picturesque peak" two to three miles east of Lafayette, "with which it is connected by a high ridge." If you know the lay of the land, then it's obvious that Sweetser is referring to the peak we now know as Mount Garfield. Back then, however, it went by a different name, and as Sweetser notes in his next sentence, "it is doubtful whether it has ever been explored, since the way thither is surpassingly difficult, leading through long unbroken thickets of dwarf spruce."

A similar pronouncement is included about the nearby peaks of North and South Twin Mountain, which up to that point had been visited by few humans, save for members of Charles Hitchcock's New Hampshire geological survey team of the early 1870s. To quote Sweetser:

> *The topography of this range is not understood nor described. Parties who intend to visit either of the Twins should advance to the head of Little River, and encamp, a short but wearisome day's journey. The next day should be devoted to the ascent and the return to camp; and the hotel would be reached on the third day. Axes will be found of material service, and clothing should be of the most sturdy character.*

As the White Mountain trail system slowly evolved over the latter two decades of the nineteenth century, Sweetser's guide evolved as well,

Celebrating the Region's Historic Past

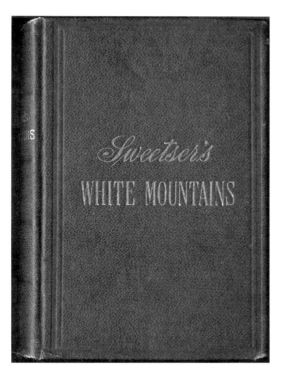

An early edition of Sweetser's popular guide to the White Mountains. First published in 1876, the guidebook was the first comprehensive hiking and visitor's guide to the region. *Author's collection.*

with updated information being included in every new edition. In the 1891 edition, for instance, Sweetser included a lengthy paragraph on the first trail cut up to the Twins following a 1882 exploration of the Twin-Bond Range led by Augustus E. Scott of the Appalachian Mountain Club (see previous chapter). Likewise, the author notes several recent excursions up to the previously mentioned Haystack, which by that time *was* being called Mount Garfield, after the late President James Garfield.

Until the AMC put out its own hiking guide in 1907, the Sweetser guide was far and away the best resource for trail information on the Whites. Even today, I find this old guide to be one of my most frequently pawed-over White Mountain books, as much for the historical aspect of the information Sweetser gives as for his early trail and route descriptions. (I've always found special favor in the fact that he devotes a full ten pages solely to a view description from the summit of Mount Washington. This description is even supplemented by a seven-panel, foldout panoramic sketch of the summit vista.) With the exception of the AMC guide, now in its twenty-ninth edition, no White Mountain hiking guide that I've ever perused has been as detailed or as entertaining to read as Sweetser's remarkable books.

The publication of this first comprehensive White Mountain guide also gave birth to an industry that has thrived for more than 125 years and continues to grow each and every year.

AMC's Venerable White Mountain Guide

Much credit for the proliferation of hiking guides to the White Mountains can be traced directly to the Appalachian Mountain Club, which over a period of several decades beginning in the late 1870s established hiking paths throughout New England's highest and best-known cluster of mountains. With the new footpaths came new guidebooks, especially in the first couple of decades of the twentieth century.

The publishing of AMC's first White Mountain guide, titled *Guide to Paths and Camps of the White Mountains*, certainly set the new standard when it first appeared in 1907. The 206-page guidebook, which sold for one dollar and covered a good portion but not all of the White Mountains region, was a solid replacement for the Sweetser guidebooks, which had gone out of print after the author's death in 1897.

The green, pocket-sized, leather-bound volume, which today is highly sought after by White Mountains book collectors, is identified on its cover as Part One of a planned two-volume set. The second volume was never published, however, and it wasn't until 1916 that AMC introduced an expanded second edition of the guide.

Like today's popular *AMC White Mountain Guide*, the original guide came with foldout trail maps—one of the Northern Peaks of the Presidential Range and one of the Southern Peaks. The book itself was broken down into eleven geographical sections, including Mount Washington, the Presidentials, the Carter-Moriah Range, the North Country, the Rosebrook and Willey Ranges near Crawford Notch, the Twin Mountain Range, Montalban and Rocky Branch Range, the Mount Carrigain Region, the Bartlett-Conway region and Jackson and vicinity. Noticeably absent, however, were sections in the western Whites, including the Franconia Notch and Moosilauke regions.

Now it can be argued that the 1907 guide was *not* the first true AMC hiking guide, because in 1882, one of the club's founding members, William H. Pickering, authored *Guide to the Mt. Washington Range*, a sleek, hardbound seventy-four-page guide and map to the Presidentials. According to the book's introduction, the map included with the guide "was intended for publication in the journal of the Appalachian Club; but when it was completed, it seemed desirable that with it should be published with descriptions of some of the more recent experiences in the region represented."

Also preceding publication of the first AMC guide was Frank O. Carpenter's *Guide Book to the Franconia Notch and the Pemigewasset Valley* (1898),

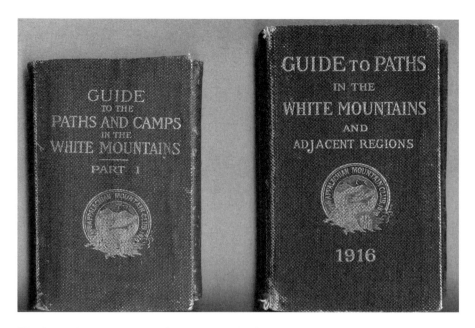

The first and second editions of the Appalachian Mountain Club's revered White Mountain guidebook. The 1907 edition, seen on the left, is among the most prized possessions of White Mountain book collectors. *Author's collection.*

the Wonalancet Out-Door Club's *Guide to Wonalancet and the Sandwich Range of New Hampshire* (1901) and the small booklet entitled "A Little Path Finder to the Places of Interest Near North Woodstock, New Hampshire," which debuted in 1905 and was published by the North Woodstock Improvement Association. Longtime Waterville Valley summer resident Arthur L. Goodrich, another AMC mainstay, also published in 1892 the handy thirty-page guide *The Waterville Valley: A History, Description, and Guide*, of which there was at least one additional updated edition issued in 1904.

A year after AMC's enlarged second edition of *Guide to the Paths and Camps* was published, the Randolph Mountain Club also introduced its first guide to the trails of the Northern Presidentials and the nearby Randolph Valley. This first edition of *Randolph Paths* was issued in 1917, and it would be another ten years before a second edition would be prepared.

In the meantime, several other interesting guides and White Mountain travelogues appeared in print between 1917 and 1927. In 1919, Allen Chamberlain's *Vacation Tramps in New England Highlands* devoted several chapters to White Mountain hikes. Winthrop Packard's *White Mountain*

Trails predated that by two years. Neither book was technically a guide but rather collections of "tales from the trail." In that same vein was J. Brooks Atkinson's *Skyline Promenades* (1925), which chronicled his two-week sojourn from the southern Whites north to Mount Washington.

The summer of 1925, however, did see the introduction of a new and entertaining guide to the Whites. Walter Collins O'Kane's *Trails & Summits of the White Mountains* was published as part of the Riverside Outdoor Handbook series and offered detailed descriptions of walks along many of the region's more popular mountain trails. This was one of three such guides penned by O'Kane in the mid-1920s. Others included guides to the Green Mountains of Vermont and the Adirondacks of upstate New York. In essence, O'Kane's guides were akin to the *50 Hikes* series of guidebooks that modern-day hikers are no doubt familiar with.

Another fascinating hiking guide that came into print in 1926 was *Trails and Peaks of the Presidential Range of the White Mountains* by Bradford Washburn, who as a teenager had previously written a book (*Bradford on Mt. Washington*) about adventuring in the White Mountains. *Trails and Peaks* was an eighty-page guide with a liberal number of photographs from the studio of Gorham-based photographer Guy Shorey. Like the Pickering guide of forty-four years earlier, it, too, came with a useful trail map, undoubtedly one of the soon-to-be-famous cartographer's earliest works.

Looking Back at One Hundred Years of the White Mountain Guide

Just as I consider Sweetser's early guidebook to be the White Mountains "hiker's bible" of its time, the enduring *AMC White Mountain Guide* has fulfilled that role for much of the last century. If the guide isn't considered an essential component of any modern-day tramper's gear arsenal, it should be, for no other single book of its kind covers as much terrain or provides as much detailed information as this venerable hiking guide

Those of us who enjoy vintage guidebooks and have a deep appreciation for White Mountains history are especially fortunate when it comes to discussion of the AMC Guide because just a few years back, when the Appalachian Mountain Club was celebrating the 100th anniversary of its first White Mountain guide, it also published a companion book detailing

the storied history of the club's signature publication. Titled *White Mountain Guide: A Centennial Retrospective*, this coffee table–sized book compiled by the staff of AMC Books and edited by Katharine Wroth is a wonderful illustrated history that in its 222 pages deftly chronicles the history of the guidebook, from its inception in 1907 right up through the publication of the twenty-eighth edition in the spring of 2007. Along the way, readers get to see how the guide has evolved over the past one hundred years while also learning much about the many individuals who toiled year after year to see that the guide was made as accurate as humanly possible.

In place of a formal "review" of the guidebook retrospective, here are a few of the more fascinating tidbits of information gleaned from its pages:

- As mentioned previously, the first edition of the guide, titled *Guide to Paths and Camps in the White Mountains*, was a 224-page volume broken down into eleven geographical sections. Unlike subsequent editions of the guide, the first edition covered only select regions of the Whites, with its primary focus being on the Presidential Range and the mountains just to the north and east. Completely uncovered, for instance, were the Franconia Notch area, Waterville Valley and the peaks of the Sandwich Range. The primary reason behind these omissions was that smaller guidebooks covering these specific areas of the Whites already existed in one form or another. Rather than duplicate information contained in these guides, AMC chose to prepare a guidebook of its own for sections of the Whites lacking such publications.

- The original intention of AMC was to publish the first guide in two parts. The 1907 edition is listed on its cover as being Part 1 of this intended two-volume guide, while Part 2 was supposed to cover all areas omitted from the first volume. Due to a combination of factors, Part 2 never was put together, so when AMC finally got around to publishing its much-anticipated second edition of the guide in 1916, all areas of the Whites were included in the new volume.

- The retail price of the 1907 edition was $1.00, with club members allowed to buy a copy of the book for even less than that ($0.80 a copy) immediately upon its official publication. The price of the guide doubled to $2.00 for the 1916 edition, and by the time the fourth edition was published in 1920, the price for a one-volume copy was up to $2.75.

- Both the 1917 and 1920 editions of the guide were offered in single and double volumes. The two-volume sets, dubbed the "field editions," meant trampers could carry with them just that half of the guide that was pertinent to the area they were exploring. From a weight-gaining perspective, this couldn't have been too much of an advantage, as the 1917 single-volume guide weighed in at a mere 10.1 ounces.

- The first edition of the book to be titled *White Mountain Guide* appeared in 1928. This seventh edition was the largest guide to date, at 546 pages. Retailing for $3.00, the guide had an approximate print run of two thousand copies—also the largest to date of any AMC guide—and weighed in at just 8.875 ounces.

- Throughout the years of the Great Depression and World War II, the retail price of the *White Mountain Guide* actually dropped from pre-Depression levels. When the ninth edition was published in 1934, the price was reduced to $2.50, and for the 1936 and 1940 editions, it was lowered to $2.25 a copy. It wasn't until the publishing of the 1948 edition that the price got back above the $3.00 mark, and by 1955, when the guide was in its fifteenth edition, the price was up to $4.50.

- The bulk of the work in preparing each edition of the guide was long the domain of AMC's guidebook committee. The original committee was composed of five individuals, including Harland Perkins, Warren Hart and Ralph Larrabee. Perkins chaired this initial effort and served on the committee for fourteen years. Hart, a Boston-based lawyer and a tireless explorer and trail builder, was a committee member for thirty-eight years and had a special fondness for the mountains of New Hampshire's North Country. Larrabee served on the guidebook committee for nearly three decades and was its chair for seventeen years beginning in 1918.

- The longest-serving guidebook committee chair was Howard Goff, who held down the post for thirty-nine years and oversaw the publication of eleven different editions. His last edition was the 1976 twenty-first edition, which coincided with the 100th anniversary of the formation of AMC.

- For the first fifty years of its existence, AMC's guidebook committee was an all-male entity. It wasn't until the 1955 edition that the committee had its first official female member (Beatrice Lord). Despite this fact, no

one can rightfully call the AMC a sexist organization since it had been accepting women into its ranks since 1876, the year it was formed.

- As anyone who collects old AMC guidebooks knows all too well, older editions are extremely difficult to find, and when you do find them on internet sites such as eBay or AbeBooks.com, the selling prices can be extremely high. The main reason these older guides are so difficult to track down is simple: there just weren't many of them printed. The print run for the 1907 first edition, for example, was just six hundred copies, while four of the next five editions had print runs of just one thousand copies each. The seventh edition, published in 1928, was the first one to have a print run of two thousand copies, and the 1936 tenth edition was the first with a run of three thousand copies. It wasn't until 1955 that the print run got above that mark, when six thousand copies of the guide went to press.

- The hiking boom of the late 1960s and early 1970s resulted in a predictably large increase in the number of books printed. The 1969 edition had a run of 28,000 copies, and the print run of the four editions published between 1969 and 1976 had a combined print run of 68,000, compared with a cumulative print run of 50,600 copies for the first seventeen editions of the guide.

- The 1983 edition of the guide, co-edited by Vera Smith and Gene Daniell, was dedicated in the memory of longtime guidebook editor Howard Goff (1894–1982), who oversaw publication of the book from 1937 to 1976. Goff was a longtime AMC member, having joined the club in 1924, and at one time worked as a hutman at AMC's Carter Notch Hut in the early 1920s. He was also a founding member of the Hutmens Association (formed in 1932) and was AMC councilor of trails from 1950 to 1952. He's also been credited as the person behind the construction of the popular Boott Spur Trail on Mount Washington and the Halls Ledge Trail connecting Route 16 south of Pinkham Notch to Carter Notch Road.

- Gene Daniell of Concord, New Hampshire, who served as editor and/or co-editor of the guide for more than two decades, was initially a member of the guidebook committee and helped work on the 1979 edition, edited by Richard Dudley. Beginning with the following edition,

published in 1983, Daniell was a guidebook mainstay for the next two and a half decades, serving as co-editor or editor for six consecutive editions, with the twenty-eighth edition (2007) being his final one. In addition to his long devotion to the guidebook, Daniell was an active member of the White Mountain hiking community and was long affiliated with the AMC Four Thousand Footer Committee. Though he's not likely to mention it himself, he was the first person to climb all forty-eight of New Hampshire's four-thousand-foot peaks in each month of the calendar, a quest that is now commonly referred to as completing "The Grid."

- Breaking with a longstanding tradition, the 1983 edition was the first to have a color photograph appear on its front cover. Previous editions bore either a hand-drawn image or the AMC logo. Unfortunately, AMC's effort to spruce up and modernize the guidebook cover was not a complete success, as the cover image they used, featuring a hiker looking over a map while atop Franconia Ridge, was mistakenly printed backward. "The photo they chose…was fairly suitable, but to our eternal embarrassment, the photo got printed in reverse, so the Liberty-Fume ridge appeared to curve to the left instead of the right as it actually does," wrote Daniell in an essay appearing in the guidebook retrospective.

- The 1992 edition, edited by Daniell, was the last one featuring trail maps originally drawn by Louis Cutter (1864–1945) and the last one put together by a guidebook committee, which was disbanded shortly thereafter. Cutter made his first map of the White Mountains in 1885 while an undergraduate in civil engineering at MIT. This map covered Mount Adams and portions of the Northern Presidentials and was a predecessor to Cutter's first AMC map, made in 1888 and covering the same Northern Peaks region. Cutter eventually mapped the entire White Mountains region, and his base maps appeared in every edition of the guide up through 1992 but were finally replaced in 1998 by new high-tech maps created by AMC's first staff cartographer, Larry Garland of Jackson, New Hampshire.

- A reorganization of AMC in the mid-1990s resulted in the elimination of the guidebook committee and the board of publications, of which it had been a subsidiary. The editor's job at that point became a paid rather than a voluntary position, with Daniell hired to serve as editor for the 1998 edition.

Deserving of Place Name Recognition

Throughout the White Mountains region, it seems that just about every noteworthy physical landmark has been given a name of some kind. Some of these names, such as Owl's Head or Sugarloaf Mountain, are of a descriptive nature, while others bear the surnames of historical figures in New Hampshire annals such as Crawford, Webster and Pierce. There are also names that honor fallen military heroes (Mount Cilley in Woodstock and Hart's Ledge in Bartlett are two examples) and names that hark back to pre-Colonial times (Pemigewasset and Saco), when the mountains were inhabited by Native Americans.

As a review of just about any detailed White Mountains map will attest, a great number of our mountain names fall into what I would term the "honorary" category. By this, I mean they bear the name of a human being who in some way, shape or form has earned honorary status in these hills and whose name it has been decided should live on forever by being attached to a mountaintop, stream, rock outcrop, hiking path or some other appropriate landmark.

For example, New Hampshire's most famous range of peaks—the Presidentials—honors a handful of early U.S. presidents (Washington, Adams, Madison, Jefferson and Monroe); the nation's only New Hampshire–born commander-in-chief, Franklin Pierce; plus several other prominent statesmen from the late eighteenth and early nineteenth centuries. Meanwhile, other Presidential Range landmarks pay tribute to scientists who conducted much work in these hills, including Edward Tuckerman (Tuckerman Ravine), Jacob Bigelow (Bigelow) and Dr. Francis Boott (Boott Spur), among others.

All over the Whites, early trail builders, settlers and once-prominent businessmen have also had their names bestowed upon various geographical features. The list seems endless, but just to name a few, there are Mounts Oscar and Stickney near Bretton Woods, named for famed hotel men Oscar Barron (Fabyan House) and Joseph Stickney (Mount Washington Hotel); the Edmands Path and Watson Path, named for trail pioneers J. Rayner Edmands and Laban Watson, respectively; and Crawford Notch and Kinsman Notch, named for the first settlers in each of these areas of the mountains.

While there are hundreds of such notable place names scattered throughout the Whites—and for the most part, I have no problem with their given names—I do believe there is at least one important historical figure who has somehow been overlooked when it comes to the name game. How

or why this has happened, I can't give you an answer. But maybe now's the time to correct this long-term oversight.

This deserving person is Moses Foster Sweetser, the nineteenth-century travel writer whose early White Mountain guidebook played a huge role in opening up the region to its first great wave of recreational hikers.

Sweetser was a Newburyport, Massachusetts native, born on September 23, 1848, and raised in a well-to-do Yankee family. At the age of twenty-one, he embarked on a self-guided, two-year tour of Europe that included at least some mountaineering ventures in the Alps. Upon his return to America in 1872, Sweetser resolved to write a series of guidebooks similar to the Baedecker series travel guides that had proved so useful to him during his European travels. Among the first projects he would tackle would be a guide for the White Mountains region.

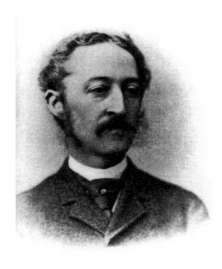

Nineteenth-century guidebook author Moses Foster Sweeter. *Mount Washington Observatory Collection.*

For what must have been several exhausting summers, Sweetser tramped all over the Whites, visiting mountaintops with crude trails already in place and many others where no trail at all existed. He was accompanied on many of these exploratory walks by Joshua H. Huntington, a former member of Charles Hitchcock's state geological survey team and, more notably, a participant in the first wintertime occupation of Mount Washington's summit in 1870–71.

As noted previously, the first Sweetser guide, titled *Osgood's White Mountains: A Handbook for Travelers*, appeared in print in June 1876, just a few months after another event that would also bring about significant new interest in the mountains of northern New England. Not by coincidence, I'm sure, Sweetser was a player in that event, too. I'm talking about the formation of the Boston-based Appalachian Mountain Club in January 1876.

As the White Mountain trail system slowly evolved over the latter two decades of the nineteenth century, Sweetser's guide evolved as well, with updated information being included in every new edition. The last of its dozen or so editions was published just two years before his premature death

in 1897 at forty-eight years of age, and up until the AMC put out its own hiking guide, the Sweetser guide was far and away the best resource for trail information on the Whites.

Considering Sweetser's invaluable contributions to the early White Mountain hiking scene, it is almost shameful that no mountaintop or stream, no backcountry pond or well-trodden footpath, has ever been named in his honor. I mean, it was just a few years ago when so much effort went into renaming one of our Presidential Range summits for a U.S. president (Ronald Reagan) who made few, if any, notable contributions to the White Mountains. Shouldn't the same kind of effort be taken on behalf of Moses F. Sweetser, a man who actually had a huge impact on this beloved mountain region?

Whether it's a rock outcropping on some godforsaken mountainside deep in the Pemigewasset Wilderness or a minor summit along one of our many ridgelines, some place in the Whites should memorialize this man. For in my mind, at least, he ranks right up there with all the legendary White Mountain trailblazers and thus should be remembered by all.

Chapter 5

Fire Towers and Their Pioneering Women Lookouts

Normally, man-made structures found atop a mountain make me cringe, but that's never been the case when it comes to forest-fire lookout towers.

Even since my first visit to a fire tower some thirty years ago, I have been fascinated by the stories behind their construction and the stories of the men and women who once manned these summit relics from the past. It goes without saying that the views from these structures have also captivated me. In these New Hampshire mountains, 365-degree lookouts are rare, so when you get one, you have no choice but to savor it.

Fire towers have been a part of the northern New England landscape for a little more than a century now. They first appeared on area summits around 1909–10 at the height of the logging era domineered by historic figures such as James Everell Henry, George L. Johnson and George Van Dyke. Following the establishment of the White Mountain National Forest, their use spread throughout the region. At the same time, the state was erecting towers on strategically located mountaintops from one end of New Hampshire to the other, as were several private entities, most notably the New Hampshire Timberland Owners Association.

For several decades, these lookouts served as the primary defense against forest fires. Personnel manning the towers from spring until fall not only scanned the mountainous country for evidence of forest fires; they also played a key role in educating the public about forest fire prevention, as the tower sites themselves had become increasingly popular hiking destinations.

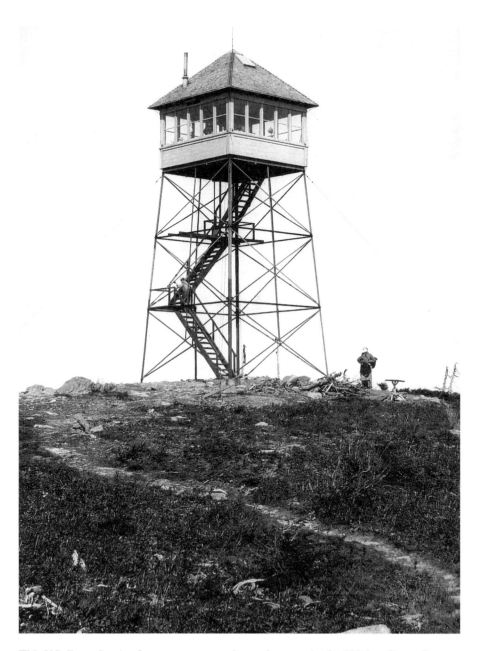

This U.S. Forest Service fire tower once stood atop the summit of 4,832-foot Carter Dome near Pinkham Notch. The steel structure was built in the 1920s. *White Mountain National Forest Archives.*

The introduction of aircraft as fire-spotting aids greatly diminished the role of the fire-tower lookout by the late 1940s and early 1950s. New Hampshire's network of towers, which once numbered more than eighty, had been reduced to less than two dozen by 1980. Today, there are fewer than twenty operating towers in the Granite State.

Over the years, this writer has been fortunate to visit just about every summit in the White Mountains that either has or once had a fire tower at its top. On some of these mountaintops, evidence of their one-time existence is obvious. On Mount Hale in Bethlehem and Mount Osceola near Waterville Valley, for instance, concrete support piers clearly show where the towers once pierced the skyline. There's also no mistaking where Mount Garfield's summit observation structure once stood, as the summit area is ringed by its concrete foundation.

Other tower sites are not as evident or accessible, however. To track down the site of a privately funded tower that once operated atop what is commonly called Northwest Hancock or Hancock Spur in the Pemigewasset Wilderness, one must undertake an extensive bushwhack either from the valley of the East Branch of the Pemigewasset River or from the valley of remote Cedar Brook. Meanwhile, relatively few hikers visit tower sites atop Mount Bemis near Crawford Notch or lowly Cooley Hill in Easton, as both are more or less off the beaten path and completely wooded and viewless.

In browsing through the useful and informative book *A Field Guide to New Hampshire Firetowers* by Iris W. Baird and Chris Haartz, it's amazing to see how many summits in the White Mountains did at one time have working towers or observatories. A partial list is as follows: Mount Attitash in Bartlett, Cannon Mountain in Franconia, Carr Mountain in Wentworth, Carter Dome near Pinkham Notch, Cherry Mountain in Carroll, Cooley Hill in Easton, Deer Mountain near Berlin and Milan, Middle Sister in Albany, Mount Cabot in the Kilkenny region of Lancaster, Mount Carrigain in Livermore and Mount Rosebrook in Bethlehem (near Bretton Woods). There are numerous others as well, not to mention additional towers that could also be found in far northern New Hampshire and in the Lakes Region just south of the Whites.

Thanks in great part to the Depression-era Civilian Conservations Corps, which during the 1930s constructed many of these towers and laid out well-built tractor roads up the mountains, a significant number of these sites remain readily accessible to today's hikers, even if the towers that once stood atop the summits are long gone. Prime examples include the

Celebrating the Region's Historic Past

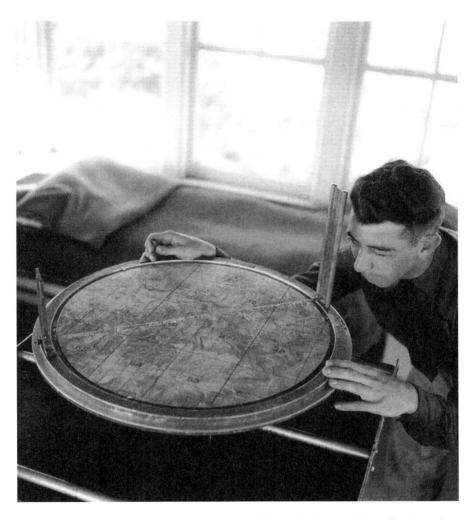

A Forest Service fire lookout working atop Mount Hale in Bethlehem sights a fire through an alidade, a device that helped pinpoint the location of a blaze. *White Mountain National Forest Archives.*

Black Mountain Trail in Benton, the little-used trail up Cooley Hill and the Sugarloaf Trail up Sugarloaf Mountain in the North Country town of Stratford (off Nash Stream Road).

For the record, only four towers remain standing in what I would call the White Mountains region. One is the restored tower atop Mount Kearsarge in North Conway, which was placed on the National Register of Historic

Places in 1991 and rehabilitated the following year. Another is the historic stone observation tower on Mount Prospect in Lancaster. Perhaps the best-known existing tower site as far as hikers are concerned is the one atop 4,647-foot Mount Carrigain, which affords one of the grandest views in all the Whites. The fourth is the 45-foot steel tower on Milan Hill (1,737 foot elevation) in Milan, just north of Berlin.

Women Lookouts on the White Mountain National Forest

Up until World War II, the role of fire lookouts in the White Mountains was strictly the domain of the male gender, with most tower personnel coming from the ranks of the state forestry department, the U.S. Forest Service, private entities such as the New Hampshire Timberland Owners Association or even the Civilian Conservation Corps.

That all changed in 1943 when, due to the war, there was a great shortage of male help and not enough men available to take over the lookout positions. Realizing that, while also knowing that forest protection services were vital to the health and well-being of the White Mountain National Forest, the U.S. Forest Service began recruiting women for the lookout posts, and for the first time ever, that summer saw a half dozen towers being "manned" by members of the fairer sex.

To prepare for their first season as fire lookouts, in April 1943, these women joined about fifty male counterparts in a three-day training school hosted by the Forest Service at the former Gale River CCC camp in Bethlehem. Described in local newspaper accounts as "intensive" training classes, it was here that the women lookouts were given instruction on the various chores they would have to fulfill during their often lonely vigils atop a New Hampshire mountain.

Dubbed by local newspapers as WOOFS—an acronym for Women Observers of the Forest Service—the women were told that their summit responsibilities would include observing their respective areas for signs of fire, acting as fire-prevention contacts with the public, maintaining their communication system between summit and base and keeping their stations clean and in good working order. They would also have to pack their own food, fuel and water supplies to the summit and, except on wet or high

humidity days, be at their posts twenty-four hours a day, seven days a week, unless relieved by a replacement lookout.

This initial crew of women lookouts in the Whites was a diverse one and included individuals from across the region and even from out of state. Barbara Mortensen of Berlin, whose husband was in the navy and "somewhere at sea" in the Pacific theater, was one of the original female lookouts and was assigned to the tower atop Pine Mountain in neighboring Gorham. Tilton, New Hampshire resident Maude Bickford, who owned and ran a general store in that town, was another of the pioneering women lookouts and was assigned to Black Mountain in Benton.

Others in the inaugural class of women lookouts included Mrs. Paul O'Neill and Miss Elizabeth Booth, both of Franconia, who volunteered as part-time lookouts atop the Cooley Hill tower in nearby Easton; Miss Elizabeth Sampson of Quincy, Massachusetts, a longtime executive secretary for the Girl Scouts of America, who was assigned to the Middle Sister lookout near Mount Chocorua in Albany; schoolteacher Helen Kurtz of Burlington, Vermont, who was to work on the Speckled Mountain tower near the Maine–New Hampshire border; and Dorothy Martin of Sandwich, New Hampshire, who would work on Mount Pequawket (or Kearsarge North) near North Conway.

For Maude Bickford, who related her experiences atop Black Mountain in a two-part series appearing that summer in the *Littleton Courier* newspaper, climbing the mountain for the first time and then reaching the summit left her with mixed feelings. "I could see the Connecticut River for miles, the Green Mountain range, and about nine towns. I realized then that the work would be hard, but to have a summer in such a beautiful spot and to be helping my country, too, was worth it," wrote Bickford. When the forest rangers who accompanied her up the mountain that day said their goodbyes and left her alone atop her 2,830-foot mountain perch, "it gave me a let-down feeling which is hard to explain. That next minute I knew, I was on my own, and what happened was up to me."

Technically, Bickford was not alone on Black Mountain, as she'd brought along her small dog, Fritz, as a summit companion. That in itself presented a few unexpected challenges, admitted Bickford, as the dog was afraid of climbing the stairs of the tower. That meant she had to carry the dog up and down the stairs whenever she had to abandon her tower perch. This was not as easy as it sounds, especially when conditions atop the mountain were windy. Describing one such instance early on in her tenure as lookout, Bickford wrote, "It was all I could do to make the tower" with Fritz in tow.

The lookout tower and cabin at Black Mountain in Benton, circa 1936. At that time, the tower was operated by the State of New Hampshire. By 1940, it was under the jurisdiction of the U.S. Forest Service. *White Mountain National Forest Archives.*

Despite the isolation of the tower, Bickford related that part of her daily routine on Black Mountain was keeping in touch with folks in the valleys, including Forest Service personnel working out of the Wildwood guard station in Easton. Typically, she would be on the phone first thing in the morning with the guard station. Then, at 4:30 p.m., she'd receive a weather update from Walter Yeaton of Benton. In turn, she would then call the Forest Service district office in Littleton, pass along the weather info she'd just received and get work instructions for the following day. Another frequent phone caller was a Mrs. Beeman of nearby Haverhill, whose husband had worked the summit tower years earlier when it was operated by the State of New Hampshire. "She has called me nearly every day…and has helped me learn the [local] landmarks," wrote Bickford. Other regular callers were her mother, who would phone her on Tuesday evenings, and her invalid husband back in Tilton, who regularly called each Saturday night.

Bickford's summer quarters were sparse, but she had an incomparable view at times, especially at sunset and during those rare, memorable nights when the lookout was able to observe the hauntingly beautiful Northern Lights.

The tower itself measured fourteen feet by fourteen feet, was surrounded by nineteen separate glass windows and offered a 360-degree view of the surrounding area. Inside the tower cab was a combination cooking and heating stove; one table; four chairs; a bed; a wood box; a cabinet where she kept food, tools, dishes and supplies; and the fire finder, which stood in the center of the room and aided her in identifying locations of smoke.

Besides looking for fires, Bickford's work duties included plane spotting (as there was always the fear of a German air attack), trail maintenance of the various footpaths leading up the mountain, gathering wood for the stove, hauling water and fighting any fire that was found within a half-mile radius of the tower. "To be a lookout you must…like the job, like to live alone, have keen eyesight, be dependable, have quick and accurate judgment, be industrious, be methodical, have perseverance, be a good housekeeper, and enjoy good health," wrote Bickford."I think living alone is the only thing I don't like. I haven't done it before, although I haven't minded it much."

Elizabeth Sampson, who worked the tower on Middle Sister that summer of 1943, also offered her insights on the job in a published piece appearing in the December issue of *Appalachia*, the journal of the Appalachian Mountain Club. For Sampson, one of the toughest tasks of her season on the mountain was the initial trek up Middle Sister that spring along the snow-laden Champney Falls Trail. Between carrying a huge load of supplies and trying to hike the trail in unwieldy snowshoes, it was a grueling first ascent that would require some six and a half hours to cover just three miles. Then, when she finally made it to the summit, she was disheartened by her first look at her summer home. "I unlocked the door and went inside. What a desolate sight!" she wrote. "The one thing I wanted to do most was to lie down and sleep. But the bed was far from inviting. At one point, I recall someone saying something about being freed from the encumbrance of luxury. My situation exactly."

But things improved quickly for Sampson, and she fell into the routine of the other lookouts spread across the White Mountains. Fire checks were made every half hour beginning at sunrise, routine checks and repairs were made to the tower telephone line, water was hauled up from a source a mile down from the summit, windows had to be washed, firewood was cut, saws had to be filed and meals had to be prepared.

One of the biggest threats to Sampson and the other lookouts was lightning storms, which aside from being life-threatening events could also do other lasting damage to the towers and the equipment. At the first sign of a thunderstorm, Sampson had a list of tasks to undertake. "The initial

precaution," wrote Sampson, "was to throw the switch on the first pole, which ground the whole telephone system. The second was to keep away from the windows, as well as from all metal, the bed, stove, fire finder, and telephone. All of this keeping away was rather difficult in a room 14' by 14' which is surrounded by windows and has the telephone and fire finder plumb in the middle." As the summer progressed, and as she became used to the sights, sounds and smells of a thunderstorm, even an especially vicious lightning storm left her unperturbed. "I just sat and watched the fireworks. I had been through enough storms by then so that all trace of fear had left me. I felt more annoyance than anything, because the storm usually interfered with such vital activities as eating and sleeping."

One highlight of a lookout's summer on the mountain was the abundant wildlife he or she got to observe on a regular basis. Rabbit, deer and bear were not uncommon sights, nor were soaring bald eagles or prickly porcupines. For observers with canine companions such as Barbara Mortensen, who owned a Great Dane, the local presence of such wildlife was not always such as good thing, as she spent a good part of two days that summer pulling quills out of her dog after it had a close encounter with the Pine Mountain porcupine population.

As things turned out in the summer of 1943, persistent wet weather reduced the number of reported forest fires in the White Mountains, and the two Franconia women assigned to the Cooley Hill tower did little or no actual lookout work, as they were obligated only to man the tower when the fire danger was high. As a result of the damp conditions, neither the Cooley Hill or Mount Garfield tower in Franconia were pressed into much service that season.

While Elizabeth Sampson's Middle Sister tower escaped any damage from the spate of lightning storms that struck that summer, the Cherry Mountain tower in Carroll, manned by lookout Ed Scott, saw its phone line heavily damaged by a lightning strike that required a half mile of new line be installed, along with a replacement lightning arrestor unit.

As for Maude Bickford atop Black Mountain, her first season as a Forest Service fire lookout ended in mid-November when the station was closed up for the winter. According to Ammonoosuc District forest ranger Alfred E. Eckes, it was an all-around positive experience for the Tilton woman, as she "was as enthusiastic about her work on Black Mountain the last day of the season as she was in April when she went to the tower."

Chapter 6

Lumberjacks and Locomotives: The Logging Railroad Era

I've never bothered to calculate just how many miles of today's White Mountains trail system can be traced back to the days of the logging railroad operators of the late nineteenth and early twentieth centuries. I'm betting it's a significant figure, though, since at one time or another more than fifteen different logging railroads worked the deep, secluded valleys of the region.

The remnants of these long-silent railroad lines is evident all through the Whites, from the lush and well-traveled valley of the East Branch of the Pemigewasset River to the rugged course of the Dry River just south of Oakes Gulf and New England's highest peak, Mount Washington. Today, over the same soil that Baldwin and Shay locomotives once hauled load after load of fresh-cut timber to mills in Lincoln, Berlin, Livermore, Conway, Campton and elsewhere, thousands of hikers make their way through the valleys and up into the mountains over terrain tamed years ago by the ambitious timber barons of a bygone era.

As there remains much interest in the former logging railroads of the region, the following pages offer a quick review of the many lines that once operated here. This will by no means be an authoritative look at their histories, but rather a brief capsule summary of each entity. For more extensive information on this subject, the best recommended resources are C. Francis Belcher's now out-of-print classic *Logging Railroads of the White Mountains*, published by the Appalachian Mountain Club, or any of the four logging railroad histories penned by retired Vermont forester and railroad

historian Bill Gove. His works include *J.E. Henry's Logging Roads*, *Logging Railroads of the Saco River Valley*, *Logging Railroads Along the Pemigewasset River Valley* and *Logging Railroads of New Hampshire's North Country*. All of Gove's books were published by Bondcliff Books (Littleton, New Hampshire) and remain in print.

Johns River Railroad: Established in 1870 by Brown's Lumber Company of Whitefield, New Hampshire, this is considered the first logging railroad line to operate in the White Mountains. While it initially operated relatively close to home (that is, in the immediate vicinity of Whitefield), the logging line, later known as the Whitefield and Jefferson Railroad, eventually extended all the way to Gorham.

Timber hauled over the line initially came from the Johns and Israel River basins but later included timber from the Cherry Pond area, the Priscilla Brook valley and from the great ravines of the Northern Presidentials in Randolph. Unlike many of the other logging lines of the day, the Whitefield & Jefferson regularly transported both logs and passengers.

Most of the timber hauled over the line was transported to the company-owned mill complex in Whitefield, which by 1887 was large enough to produce 23 million board feet of spruce and pine lumber annually. As was typical with these large-scale timber operators, much of the actual harvesting was done during the winter months, when Brown's Lumber Company employed as many as three hundred men in the woods.

In the course of its existence, the logging line employed five different locomotives, including its first, named Pony. This ten-ton locomotive, originally built in 1839 by the Locks and Canals Company of Lowell, Massachusetts, would wind up plying the northern New Hampshire woods for more than a quarter century, working on both the Johns River and Zealand Valley Railroads.

The Whitefield & Jefferson Railroad was eventually purchased in 1889 by the newly established Concord and Montreal Railroad, which then leased the line in 1895 to the Boston & Maine Railroad. The big mill at Whitefield and all of Brown's Lumber Company's extensive land holdings were later sold to renowned North Country lumberman Cassius Twitchell and his Berlin Timberland Company in July 1902.

Lancaster and Kilkenny Railroad: For ten years (1887–97), this line operated between Coos Junction in Lancaster and Willard Basin on the western slopes of the Pilot Range east of Lancaster. Timber cut from the

slopes of the Pilot Range and from the north and west slopes of the adjoining Starr King Range peaks accounted for most of the line's cargo.

The ten-mile line, which ran to the base of Round Mountain, was owned by business interests from Littleton and Lancaster in partnership with the Boston and Lowell Railroad, which financed most of its construction. At first, most of the timber was transported to several different mills in Lancaster, but during its later years, when Littleton interests (including Henry C. Libbey and Charles Eaton) took over most control of the line, the harvested timber was sent to the Littleton Lumber Company mill in the Willowdale settlement near the Lisbon town line.

On January 31, 1890, tragedy struck the Lancaster and Kilkenny Railroad when the locomotive Triton, operated by engineer Leonard Crouch, was unable to negotiate a sharp curve and crashed, killing the veteran train operator. The story of the tragic accident is retold in the chapter titled "Crash of the Triton."

The upper portion of the old logging line may be followed today along the York Pond Trail from East Lancaster. However, due to an ongoing landowner dispute, access to this end of the trail is not currently available.

Wild River Lumber Company Railroad: This fifteen-mile-long line, which operated from 1891 to 1904, followed the Wild River deep into the Evans Notch area near the Maine–New Hampshire border. It connected with the Grand Trunk Railway to the north at the small hamlet of Gilead, Maine. It was formed by Vermonters Samuel Hobson and his partners Eben C. Robinson and George Fitzgerald after they purchased some thirty-seven thousand acres of timberland in the Wild River basin.

In its course, a number of spur lines branched off the main railroad line, most notably those following Moriah, Bull, Spruce and Red Brooks. Of these, the Moriah Brook spur was the longest, at three miles, and it featured a huge trestle near Moriah Brook Gorge that was believed to be the largest such structure in the North Country. At its zenith, there were as many as six operating logging camps in the Wild River valley, each employing between forty and sixty workers.

Just a couple of miles up the line from Gilead was the small logging community of Hastings, which featured mills, a school, a general store, a boardinghouse and numerous small homes for workers and their families. Under ownership of the Hasting Lumber Company, which took control of the Wild River operation in 1898, daily production at the company's Hastings sawmill was as high as sixty-five thousand board feet.

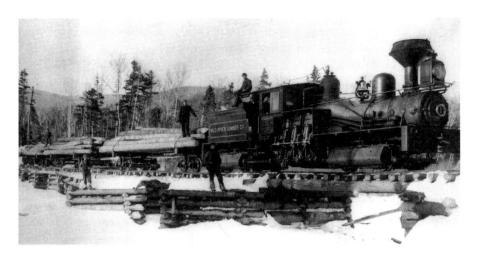

Shay No. 1, the Gilead, and its crew take a break on a trestle along the Wild River Railroad. *From* Logging Railroads of New Hampshire's North Country *(2010)*.

The village of Hastings and its attendant logging operation suffered back-to-back setbacks in 1903. First, a spring freshet in mid-March inundated the town and washed away much of the railroad track. A few months later, following an exceptionally dry spring, a massive forest fire apparently caused by careless fishermen began at the head of the Wild River near Perkins Notch, burning thousands of acres of timberland, including extensive swaths on the eastern slopes of the Carter-Moriah Range. (A fire in the Moriah Brook valley eight years earlier had also consumed nearly five thousand acres of woodland.)

Also destroyed in the 1903 inferno were several logging camps, four landings of logs piled trackside, and much of the railroad line, which had also sustained damage in the March flooding. As a result of these twin misfortunes, large-scale logging at the upper end of Wild River came to an unanticipated end in the spring of 1903. And though the rail line between Hastings and Gilead was restored within two months, no log trains ever again steamed their way up into the Wild River basin. In fact, all railroading on the line, even into Hastings, had ended by the following year.

Modern-day visitors and hikers to this area near the eastern boundary of the White Mountain National Forest should note that both the Wild River Trail and the Moriah Brook Trail follow major segments of the old logging railroad grade.

Upper Ammonoosuc Railroad: This remote railroad (1892–1903) operated in the Kilkenny area of the North Country east of Mount Cabot and the Pilot Range. In its eight-mile course, beginning near West Milan, it primarily followed the Upper Ammonoosuc River and its West Branch, with an additional four miles of spur lines extending along today's Unknown Pond Trail and from York Pond west toward Terrace Mountain.

The rail line was the brainchild of the operators of the Lancaster & Kilkenny Railroads, and in August 1892, there were one hundred men—many of them Italian immigrants—working on construction of the rail bed. By December, the first load of cut logs arrived at the main Grand Trunk Railway line in West Milan. From there, the cut timber was delivered by rail to operating interests in the Berlin-Gorham area, including the Glen Manufacturing Company, a paper manufacturing entity. A few years later, the Ammonoosuc Lumber Company constructed its own sawmill in West Milan and began processing cut timber on its own.

The dry summer of 1903 spelled the end of logging operations in the Wild Ammonoosuc basin when a devastating forest fire covering more than twenty-five thousand acres of timberland left the area little but a wasteland. With the fire having consumed nearly 70 percent of the standing timber in the area, there was little reason for logging to continue.

Little River Railroad: This short, six-mile line was established in 1893 by North Country timber tycoon George Van Dyke, who was far better known for his great Connecticut River log drives than his efforts at running a railroad. The Little River operation in Twin Mountain and Bethlehem was, in fact, his lone New Hampshire excursion into the world of logging railroads.

Timber harvested in the valley separating the Little River Mountains and the Twin Range was transported to James Everell (J.E.) Henry's Zealand village sawmill a short distance east of Twin Mountain village. The timber supply was relatively scant in the Little River valley, and by 1900, the merchantable timber had been exhausted, and railroad logging had ended.

The first couple of miles of today's North Twin Trail follow the old railroad grade.

Zealand Valley Railroad: White Mountain lumber king J.E. Henry established this eleven-mile railroad into the pristine Zealand River valley in 1884. It was originally hoped that the line would be extended right down through the Pemigewasset River valley and on to Lincoln, but no such extension was ever built.

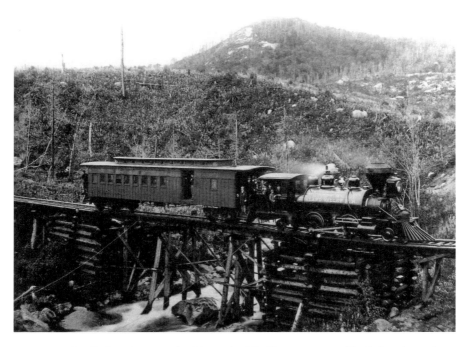

Zealand Valley Railroad locomotive No. 1, the J.E. Henry, stops on Hoxie Brook trestle while transporting a carload of dignitaries to one of the line's remote logging camps. *Author's collection.*

Beginning at Zealand village, the line followed the Zealand River to its source at Zealand Pond, at which point it hugged the lower slopes of Whitewall Mountain through Zealand Notch before branching off toward remote Ethan and Shoal Ponds. The railroad line was renowned as one of the steepest and crookedest in existence, with many river crossings and numerous steeper-than-usual pitches.

Henry's loggers worked the valley intensively from 1884 to 1892, clearing just about every merchantable tree in sight. What *they* didn't get, fire did. A great conflagration in July 1886 destroyed an estimated twelve thousand acres of prime timber. Several years after Henry's loggers had left Zealand for the untouched woods of the East Branch of the Pemi, another huge forest fire blackened ten thousand additional acres in the valley.

Zealand village, which included a sawmill, boardinghouse, post office, company store, two rail depots and several other structures, was at one time a bustling little community with as many as 250 people living in or near it. The rail operation at Zealand included an engine house and repair shop on

the south bank of the nearby Ammonoosuc River. Deeper into the forest, along a spur line of the railroad, existed a half dozen or so charcoal kilns alongside the Zealand River. Here, four-foot hardwood timber was dumped into the large, rectangular brick kilns and then burned at a relatively low temperature for hours, the end product being shipped to points south of the White Mountains.

At one time or another, there were at least eight logging camps situated along the Zealand line. During winter operations, Henry employed as many as 275 to 300 men and two hundred horses in the Zealand Valley woods; that number was reduced to 80 workers or fewer during the slower summer months. In the first winter of operation at Zealand, about 13 million board feet of lumber was cut by Henry's logging crews. During its lifetime, the annual yield of Zealand-cut spruce was 15 million board feet.

Hikers visiting the Zealand River valley today may follow the old railroad grade via the Zealand, Ethan Pond and Shoal Pond Trails.

Saco Valley Railroad: This short-lived (1892–98) line ran a little under seven miles from the old Fred Garman mill at the south end of Crawford Notch up the Dry River (Mount Washington River) valley toward Oakes Gulf and Mount Washington. The Saco Valley Lumber Company owned cutting rights to the valley but, in an unusual agreement for the times, was prohibited from cutting any tree eight inches or less in diameter and had just fifteen years to remove any and all timber.

The railroad into the Dry River proved to be an expensive one to operate, owing to the narrow and rugged nature of the valley. In one four-mile stretch, the line reportedly crossed the river on trestles more than a dozen times. Washouts or trestle failures were a recurring problem for the line's owners and added to the financial burden of owning a logging railroad line in such an inhospitable mountain valley. From beginning to end, the line climbed an impressive 1,300 feet in elevation, with an average grade along the way of 6.5 percent.

Railroad operations were centered at the settlement known as Carrigain village, not far from today's Notchland Inn. Like many such logging communities of this era, the population swelled to several hundred persons during the heyday of the logging line, but as soon as timber operations ceased, the village more or less disappeared from sight. The settlement included the main office of the Saco Valley Lumber Company, several tenement houses, the company store, a school and a sizable train station with a full-time agent.

Much of the valley that was once traversed by logging trains is now a designated federal wilderness area situated in the White Mountain National Forest. The Dry River Trail, which begins off Route 302 in Crawford Notch State Park about a half mile west of Dry River Campground, follows a good portion of the old railroad grade, but due to flooding associated with Tropical Storm Irene, which struck the region in late August 2011, the hiking trail has been closed to public use.

Sawyer River Railroad: This logging line, founded in 1877 by lumber barons Daniel and Charles Saunders, ran eight twisting miles up the Sawyer River valley, starting at its junction with the Maine Central line in Hart's Location and extending on into the now-abandoned town of Livermore and then to the base of distant Mount Kancamagus.

The base of operations for the railroad and its mills was the then-thriving lumber village of Livermore, which is all but gone today save for one small privately owned home. The village was located about 1.8 miles up the Sawyer River from the Livermore depot along the Portland & Ogdensburg Railroad through Crawford Notch. By 1880, there were at least twenty simple dwellings in the village, states historian Bill Gove, and the population exceeded one hundred persons. The village also featured a company owned, moderate-sized sawmill and a schoolhouse that reportedly had as many as twenty students at various times during its existence.

Over the years, at least seven logging camps were established along the Sawyer River line, with the two farthest camps situated on the lower slope of Mount Kancamagus not far from today's scenic Kancamagus Highway. Because the Saunders brothers often practiced selective cutting, their timber resources far outlasted those of other White Mountain loggers. The fact that their Livermore village sawmill was also relatively small for the times and could not handle the volume that others in the region could probably played a part as well in the lengthy operation of the railroad line.

It was Mother Nature, not a lack of trees to cut, that ultimately led to the closure of the Sawyer River Railroad. The destructive flood of November 1927 was the culprit, as damage caused by the rain-swollen Sawyer River left the railroad beyond feasible repair.

The upper portions of the Sawyer River railroad grade may be followed today along the Sawyer River Trail, which runs 3.8 miles between the Kancamagus Highway and the terminus of the Sawyer River Road in Livermore.

Bartlett and Albany Railroad: Originally established by the Bartlett Land and Lumber Company in 1887, this ten-mile logging railroad ran from Bartlett village to the Passaconaway settlement in Albany. As originally chartered, it was to connect with the proposed Swift River Railroad planned by Daniel Saunders, but no such line was built, or at least not until after the Bartlett and Albany Railroad ceased to exist. Timber resources along the railroad included the slopes of Bear Mountain and Mount Tremont and various drainages along the Swift River near Albany.

As the grade of this railroad ran up and over Bear Notch, this line was unique in that it required its engines to climb over the height-of-land of the mountain pass twice on a round-trip excursion. This placed a limit on the amount of timber that could be hauled out at the end of the day, since a fully loaded train wouldn't be able to climb over the pass.

Just one locomotive, making a single round trip a day, operated on the railroad. The newly purchased mogul locomotive was bought from the Portland Company and delivered in March 1887. Bearing the name Albany, the coal-burning locomotive was housed at the Maine Central Railroad's six-stall engine house in Bartlett, where it was regularly serviced.

The principle species harvested by lumbermen working along the line was spruce, though some hemlock and hardwood logs were also hauled out of woods and transported by train back to Bartlett. Any white birch cut was taken to the Kearsarge Peg Company mill in Conway, while hemlock bark was harvested and taken out in sheets and delivered to area leather-tanning interests.

After operations ceased in 1894, the rails remained in place for a number of years, but no further railroad logging was to come. It wasn't until 1907 that the track was taken up for good. Some years later, much of the grade was converted to a road and today serves as the base of the scenic Bear Notch Road. Other sections of the old grade may be followed today along the Rob Brook Trail near the southern end of the line.

Rocky Branch Railroad: One of three logging railroad lines operated by the Conway Company of Conway, this twelve-mile line ran from Glen, New Hampshire, up the little-traveled Rocky Branch valley, ending just east of Mount Isolation and the Montalban Range. At the upper end of the line, known as Engine Hill, the grade was exceptionally steep at 9 percent or greater. This created more than a few challenges for train operators, especially when hauling full loads of cut timber.

The Rocky Branch Railroad ran from 1908 to 1914 and would undoubtedly have run longer if not for a series of forest fires that burned

an estimated 57 percent of its standing timber between 1912 and 1914. The largest of these fires occurred in the summer of 1912 and burned for nearly two weeks, torching more than thirty-five thousand acres of timberland.

The aptly named Rocky Branch hiking trail follows, for the most part, the grade of the old railroad. Due to flood damage sustained in August 2011, the southern portion of this U.S. Forest Service trail remains closed to public use as of 2013.

East Branch Railroad: Another Conway Company railroad, this thirteen-mile line followed the East Branch of the Saco River from Glen into Chatham, New Hampshire. One spur line extended near Mountain Pond, the other farther up the valley to the west of Sable and Chandler Mountains.

Serviced by two Climax locomotives, the railroad operated for a short but intense period (1916–20) and marked the end of logging railroad ventures by the Conway Lumber interests.

Portions of the old railroad may be followed today on the East Branch hiking trail off Slippery Brook Road in Chatham.

Swift River Railroad: This logging railroad was organized by the Conway Company in 1906 and ran for eleven years (1906–16) in the valley of the Swift River. The present-day Kancamagus Highway, or at least the eastern half of the Kanc, pretty much follows the old railroad grade from the site of the Conway Company's mill in Conway up past Pine Bend Brook and on toward Lily Pond near the height-of-land along the Kanc.

The Swift River line ran for approximately twenty miles, which included several side tracks and spurs. One of the lengthier spurs ran along Oliverian Brook in Albany and is followed for a distance today on the Oliverian Brook Trail. Another spur was located near present-day Bear Notch Road.

With plenty of timber to harvest and lots of acreage to work with, the Swift River operation was a labor-intensive effort, with as many as one thousand men employed in the woods from 1907 to 1909. They worked out of nearly a dozen remote logging camps found from one end of the line to the other, with Camp Six near Pine Bend Brook the most distant of the camps.

Logging operations along the Swift River were intense and are chronicled in part in two well-known books from the early twentieth century: *Passaconaway in the White Mountains*, by Charles Edward Beals, and *At the North of Bearcamp Water*, by Frank Bolles.

James Everell Henry. *Author's collection.*

East Branch & Lincoln Railroad: The granddaddy of all White Mountain logging railroads, the EB&L was formed by James E. Henry in 1893 and operated continuously for more than fifty years (1893–1948). Besides lasting longer than any of the other logging lines, the EB&L was by far the most extensive rail operation, with an estimated fifty miles of track. The rails extended deep into the forests of the central White Mountains, running from Lincoln up along the East Branch of the Pemigewasset and its many tributaries, including Franconia Brook, the Hancock Branch and Cedar Brook. It is estimated that more than 1 billion board feet of timber was harvested from the vast East Branch country during the life of the EB&L.

Timber cut along the East Branch and its tributaries was hauled by rail to Lincoln, where Henry and his successor, Parker-Young Company, operated a paper mill and sawmill. The village of Lincoln pretty much owes its existence to Henry. Prior to his arrival in 1892, the town was more or less a wilderness outpost with few settlers and little industry.

The line's founder, J.E. Henry, was certainly one of the most controversial figures of his time. His penchant for clear-cutting the forest was reviled by many and earned him the names "wood butcher" and "mutilator of nature." He was a strict, authoritarian figure with good business sense, a domineering personality and "hard-driving acquisitiveness," wrote Bill Gove in his book *J.E. Henry's Logging Railroads*. Despite his well-earned reputation, the Lyman, New Hampshire native engendered a loyalty among his men unmatched by few of his era. Many of the men working for him on the EB&L had previously worked for Henry on his Zealand Valley Railroad. "Henry was strict and often tight, but he treated his men well," added Gove.

Henry's extensive woods operation (and that of his successors) included some two dozen remote logging camps, some more than a dozen miles from Henry's mill complex in Lincoln. It was not unusual for Henry to have five camps working simultaneously in the winter, with as many as five hundred men toiling in the woods. The camps along the EB&L were considered

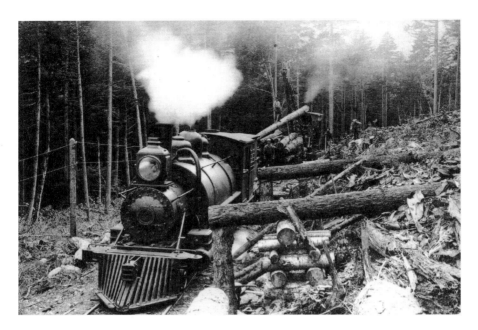

Baldwin No. 4 works the woods on the East Branch & Lincoln Railroad in the summer of 1907. Here, crews are picking up logs once used for cribbing on a loading platform. *Author's collection.*

Camp 8 on the main line of the East Branch and Lincoln Railroad as it appeared in 1901. *From* J.E. Henry's Logging Railroads *(2012).*

"comfortable" accommodations for the hardworking loggers, especially when compared to the rough, raw camps he used in his Zealand operation.

Henry famously posted at each camp a list of forty-seven rules and regulations that he fully expected his employees to follow. Many had to do with the treatment of the camp horses, which he highly valued, while others dealt with care of equipment and personal behavior at the camps. One can only speculate on the reasons why Henry decided to include the following rule: "Any person found throwing food or making unnecessary or loud talk at the tables will be fined."

As was the case with Henry's logging operations in the Zealand River valley two decades earlier, a substantial amount of potential timber product in the East Branch country fell victim to fire. The so-called Owl's Head fire of August 1907 was ignited by a lighting strike near Camp 9 Brook in the Franconia Branch drainage. Visible for miles, the conflagration consumed timber on both sides of the Franconia Branch valley all the way up to Mount Garfield. When the fire finally burned itself out several weeks later, some thirty thousand acres of timber had been destroyed.

Five years after J.E.'s death in April 1912, his sons opted to sell off the Lincoln mills and company-owned timberlands to Parker-Young Company, which continued to operate the EB&L until it, too, sold off its holding in 1946. The last trains to run on the remnants of the EB&L did so in 1948.

Today, many hiking trails leading into the federal Pemigewasset Wilderness follow the old EB&L grades. The best known of these include the Lincoln Woods and Wilderness Trails, the Franconia Brook Trail and the Hancock Notch Trail.

Gordon Pond Railroad: Another Lincoln-based operation, this railroad was run by the Johnson Lumber Company and extended up into the Lost River valley of neighboring Woodstock. Spur lines ran toward Gordon Pond, Elbow Pond and along Jackman Brook in Woodstock and up toward Hardwood Ridge on the east side of the Pemigewasset River in North Lincoln.

Logging operations up toward Lost River were especially intense, as Johnson Lumber had only ten years to harvest all the standing timber in that area. To fulfill contractual obligations, the men working for owner George L. Johnson of Monroe, New Hampshire, harvested an average of 14 million board feet a year. Along the Elbow Pond branch, timber was cut on Mount Blue, Mount Cushman, Green Mountain and Mount Cilley.

Johnson incorporated the Gordon Pond Railroad in 1907 and immediately began building a railroad line that would eventually include fifteen miles of

track. The only locomotives used on the Gordon Pond Railroad were Shay-geared locomotives. The first one purchased for the railroad was a new fifty-tonner dubbed the Mary Gray. Three additional locomotives, all formerly used on the Moose River logging railroad in Essex County in Vermont, were also used by Johnson's men.

Johnson's Lincoln operation was headquartered in a small settlement known as Johnson on the north edge of town. Here, he operated a sizable sawmill, built a boardinghouse for the mill workers and purchased several other small dwellings in the vicinity. Johnson's general manager of the entire operation was James "Jakey" McGraw of Lunenburg, Vermont, who was well known in lumbering circles as a highly capable woodsmen always up for a challenge.

Although the Gordon Pond Railroad was officially in business from 1907 to 1916, it saw only limited traffic over its final few years of operation, as most of the prime spruce had already been harvested by then. For a few years, the line hauled cut hardwood timber to a short-lived floor-manufacturing mill in Lincoln. A fire at that mill, plus a subsequent blaze in 1915 that destroyed the Johnson sawmill, pretty much forced operations to finally cease.

Woodstock & Thornton Gore Railroad: This short-lived (1909–14) line ran from the Woodstock Lumber Company's mill along the Pemigewasset River in Woodstock up into Thornton Gore, following pretty much the grade of today's Tripoli Road. The line ran for at least seven miles, running up toward East Pond and Little East Pond south of Scar Ridge. The railroad also serviced a former Tripoli mill located near East Pond.

According to historian C. Francis Belcher, the Woodstock & Thornton operation was a simple one in terms of rail operations because other than the separate line to the Tripoli mill, there were no spur lines and few sidetracks. "For engineers and trains crews, it ran simple in-and-out train operations," wrote Belcher.

The Woodstock & Thornton Gore Railroad saw its existence cut short when an August 14, 1913 fire destroyed the Woodstock Lumber Company's massive mill complex at the west end of the logging railroad line. The fire, which was caused by sparks from the yard locomotive, quickly consumed not only the sawmill but also numerous adjoining structures, about fifteen homes, a post office and a substantial amount of valuable sawn lumber.

Beebe River Railroad: This was the southernmost logging line in the Whites, running approximately twenty-five miles from Campton all the way to Flat Mountain Pond at the base of the Sandwich Range. The railroad

was jointly built by the Woodstock Lumber Company and Parker-Young Company. During its lifetime (1917–42), about a dozen different logging camps came into existence along the rail route, and in its heyday, more than four hundred men were employed in the woods, with five trains a day, running seven days a week, hauling cut timber out of the woods. The line was also well known for its many trestles, including one that was 175 feet long and 39 feet high.

For the first seven years of its existence, mostly spruce was hauled out of the woods and taken by train to operating mills in Campton (Beebe River) and Lincoln. The quality and size of the spruce, especially above remote Flat Mountain Pond, was reportedly exceptional. After the line was purchased by Draper Corporation in 1924, hardwood was the prime target of loggers. The company's large sawmill at Beebe River, which cut its first log in November 1917, was capable of sawing over 100,000 board feet on a good day, and during World War II, much of the high-grade spruce cut at the mill was used in the manufacture of airplanes for the U.S. military.

For the most part, Shay-geared locomotives were used on the Beebe River line, though one newly built Climax-geared locomotive was added to Parker-Young's fleet of engines in 1921. This aging Climax is still in operation at Clark's Trading Post in Lincoln.

The devastating Flat Mountain fire of July 1923 destroyed much prime timber in the area. The blaze, one of the most intense in White Mountain annals, burned uncontrolled for four days and consumed about 3,500 acres of forestland. Remarkably, it was still burning in the ground more than two months after it started. One fifty-year-old woodsman, John Gray, perished in the fire when he was unable to outrace the approaching flames after fleeing from Woodstock Lumber Company's Camp 12.

In the aftermath of the fire, state forester John H. Foster placed the blame for the fire squarely on the shoulders of the Woodstock Lumber Company, which he charged was operating in a reckless manner at a time when dry conditions throughout New Hampshire meant the risk of forest fires was high. "You were operating in the midst of conditions which made a fire like the recent one not a possibility but almost a certainty…yet you do not appear to have taken seriously the risk you were running," wrote Foster.

Good sections of the former railroad grade can be followed today by hikers on both the Flat Mountain Pond and Guinea Pond Trails.

Success Pond Railroad: Operated by the Blanchard and Twitchell Company of Milan, this logging railroad ran from Berlin northeast into

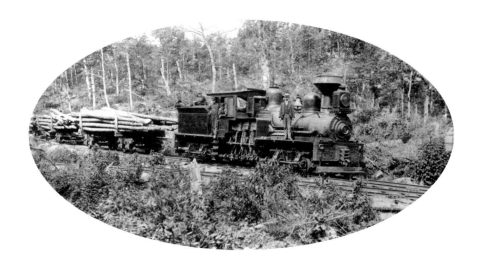

Blanchard and Twitchell's Shay No. 6 worked on both the Success Pond and the Wild River Lumber Company Railroads. *From* Logging Railroads of New Hampshire's North Country *(2010).*

the uninhabited town of Success and on to remote Success Pond. The line itself was about fourteen miles in length, while a dozen or so spur lines added another fifteen miles of track. Two of the longer spurs ran east toward the Mahoosuc Range, with the Camp 9 spur running toward the lower western slopes of Goose Eye Mountain and the longer Camp 6 spur running east toward wild Mahoosuc Notch. The railroad operated from 1894 to 1907.

At the height of the timber-harvesting season, the Success woods operation of Blanchard and Twitchell employed as many as four hundred to five hundred men. Many of these workers were lodged at the company's numerous camps along the line, including one of the largest of them all, Camp 9, which also housed a working farm and huge horse barn. In a typical year, the railroad hauled out 25 to 30 million board feet of timber, with most, if not all, of the wood going to the Berlin Mills Company facilities in Berlin.

Today's rough-and-tumble Success Pond Road follows the grade of this old logging railroad line.

Chapter 7

Crash of the Triton (and Other Log-Train Mishaps)

The logging railroad era in the White Mountains has been well chronicled over the years by historians such as the late C. Francis Belcher of the Appalachian Mountain Club and author Bill Gove of Williamstown, Vermont. Through their respective books, local history buffs have enjoyed reading of this colorful age when timber barons such as James Everell Henry and Daniel and Charles Saunders sent whole armies of men into the woods to harvest the vast, untouched forests of the region.

As evidenced by these writings, the lumberjacks and logging railroaders were a hardy bunch who were pushed to the max each and every winter. The perils of working in the woods or on these remote backwoods rail lines were plentiful, and no doubt many accidents of note took place, probably on a regular basis. Unfortunately, some of these incidents had tragic results.

One such occurrence, which took place more than 120 years ago, on January 31, 1890, was the fatal crash of the logging locomotive Triton, which was being utilized on a temporary basis on the Kilkenny Lumber Company railroad line between Lancaster and Willard Basin on the west side of the Pilot Range mountains. The engine, pressed into service a day earlier after the line's regular log-hauling locomotive, the Mount Washington, was idled by a blown cylinder head, was only a year old but had been used primarily for shunting cars around in the yards of the Concord and Montreal Railroad. As it turned out, it was no match for the larger, more dependable Mount Washington.

With engineer Leonard Crouch at the helm, Triton was pulling a string of about a dozen cars loaded with upwards of sixty thousand board feet of logs

when a coupling pin between two of the cars snapped, sending the engine and the front cars careening down the steep, crooked rail line running out of Willard Basin. It was a frightening scene, best described below by Bill Gove in his book *Logging Railroads of New Hampshire's North Country*, published in 2010 by Bondcliff Books of Littleton:

> *With the hand brakes set, Crouch began the steep descent at a speed of ten to fifteen miles per hour, the most that could be expected on a course that dropped 800 feet in three miles, averaging five percent in grade. After passing Button's Landing, the train reached a sag in the grade…and Crouch gave the load a little power boost to carry it up over the sharp rise at the end of the sag. There was a sudden strain on the link and pin couplers as the load shifted from gravity momentum to engine pull, and the coupler links clanked against the pins, straining to part. The sudden wrench was too much for one of the pins, the one linking the fourth and fifth log cars, and it sheared through, dropping from place. The train parted, dropping off eight log cars and the caboose, and disaster began to ride the rails. Death was riding an iron horse.*
>
> *The Triton, with its reduced load of four cars, passed on through the "Orchard" and pitched over the rise. By now, Len Crouch was painfully aware of what had happened to his train consist and was acutely attentive to the danger that now lay immediately ahead of him. The train speed increased to twenty-five or thirty miles per hour as he sped down through "Hartford's Woods," the increased speed due in part to the loss of the nine cars with brakes set tight to hold him back.*
>
> *Crouch had air brakes on the locomotive and tender, but now he dared not use them for fear of lifting the tender from the crooked track at what now was a hurtling descent. Although he couldn't see behind him, he supposed the parted section might be close on his heels, and a rear-end boost would be fatal at this tense moment. He wanted to brake but feared to. Unseen and immeasurable dangers were hurtling toward both ends of his nearly runaway train, or so it seemed.*
>
> *White knuckles gripped the throttle as Len Crouch peered through the pelting rain. He was now about a quarter of a mile below the last hilltop, the reverse curves were coming on him fast, and the two ribbons of steel could scarcely contain the swaying* **Triton**. *It was too late now to even think of braking; he could only hope that by some sort of miracle the careening locomotive would stay on the rails. But the worst was yet ahead, and then, with eyes almost pinched shut against the wind and rain, Crouch suddenly saw the first sharp curve coming toward him with blinding speed.*

"Jump," he hollered to fireman Will Balch, who climbed up into the window and leaped towards the bank speeding by, just before the front wheels touched the beginning of the curve. When the Triton hit the curve, it never slowed a bit, nor did it deviate much from a straight line. With a horrendous crunch, thirty-two tons of hurtling metal slammed into the frozen bank fringing the lower side of the reverse curve. The light tender and four log cars lifted from the tracks and propelled through the air, catapulting on top of and even beyond the steaming wreckage wherein lay trapped Len Crouch.

The binder chains quickly parted, and twenty-foot long spruce logs came hurtling down, ramming and rolling over the still mobile wreckage. Some of the debris landed on fireman Balch, where he lay stunned after rolling along the ground. But the fatal punch came as one spruce log smashed through the cab wreckage and pinned the petrified Len Crouch against the hot boiler, followed by another spruce missile which split open and sheared off part of his head. Death had claimed a quick victim.

Within seconds, all was quiet through the Hartford's Woods—all, that is, except for the eerie wail of Triton's whistle. It had become stuck open at the crash and continued to proclaim the calamity until all of the boiler's steam was spent.

Within a few minutes, the other eight log cars came slowly rolling down the track, not hot on the heels of the speeding train heading for calamity, but poking along at three to four miles per hour with brakes set tightly. The horror of the scene stunned the men as they ran forward from the saloon car. Balch was pulled out from under the jack-strawed logs, alive but badly hurt, but for Crouch, it had been his last trip.

In its report on the train wreck a week after the event, the Lancaster-based *Coos County Democrat* noted that Crouch, from North Haverhill, was about thirty years of age at the time and though unmarried was engaged to a woman from Lancaster. His surviving family members included his mother and one sister.

The paper reported that the accident scene was a grisly one, but that did not prevent it from offering up details that seem harsh by today's reporting standards. "When the body was recovered, it was found to be horribly mutilated and so burned that large pieces of flesh dropped off," reported the *Democrat*. For those local residents who had not made it out to the scene of the accident, three photographic images of the site enabled all who wished to survey the wreck secondhand. The images, taken by a local photographer, were promptly made available for purchase at the photographer's local art gallery.

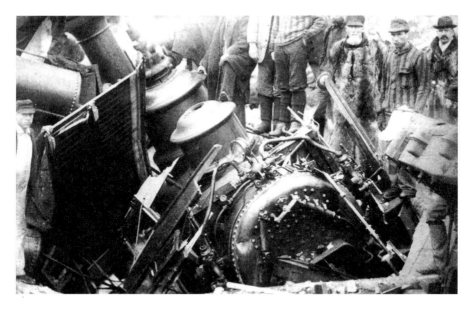

The front boiler of the demolished Triton is visible in this image taken in the aftermath of the January 31, 1890 incident on the Kilkenny Lumber Company Railroad. *From* Logging Railroads of New Hampshire's North Country *(2010).*

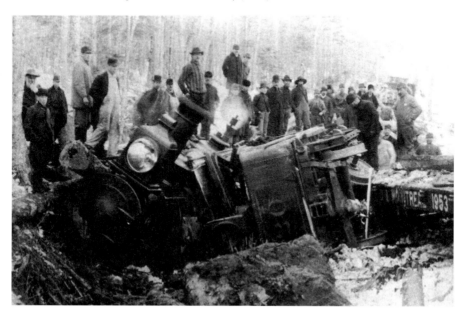

Curiosity seekers view the wreckage of the train crash that claimed the life of engineer Leonard Crouch. *From* Logging Railroads of New Hampshire's North Country *(2010).*

Trouble on the Tracks

Fortunately, the Triton's one and only run into the Kilkenny woods was the lone major catastrophe in the decade-long history of the logging railroad. But that's not to say there weren't others in and around the White Mountains, for there certainly were. Here's a quick rundown on a few other noteworthy train- and logging-related mishaps during this colorful but often dangerous era:

April 4, 1894: A train working its way along the Wild River Railroad rounded a curve and suddenly came upon a landslide that had completely blocked the tracks. Engineer Thomas Hudson tried his best to try and stop the train before it ran into the debris. He was not able to halt the advancing engine, however, and when the train hit the dirt slide, it did so with enough force that the locomotive tipped over, crushing the engineer to death in the process.

July 16, 1896: A fully loaded train on the Dry River Railroad was working its way down the valley when the brakes failed on the Shay locomotive operated by engineer George Woodward. As the train began to pick up speed and careen out of control, Woodward decided it was better to "jump ship" than risk injury in an inevitable crash. Unfortunately, he leaped right into a trackside boulder, which he struck with his head. Death was instant. A similar fate was met by twenty-eight-year-old brakeman John Murray, who eventually died from injuries sustained in his leap of faith. Several other crew members received non-fatal injuries when they attempted to jump off the train, while three other riders stayed with the runaway and somehow escaped serious injury, even though the train did eventually jump the tracks and derail.

April 18, 1898: In one of the worst logging railroad disasters in White Mountain history, three of four crew members on a Wild River log train were killed instantly when the boiler on Shay No. 1, the Gilead, inexplicably exploded as the train was working its way down the line near Camp 5. Though it was never determined exactly how or why the explosion occurred, speculation is that engineer Harry Belmont let the water level get too low in the boiler and that the fire below the boiler burned through the casing, causing the eruption. Killed along with Belmont were fireman Everett Johnson and brakeman Cyril Lamore.

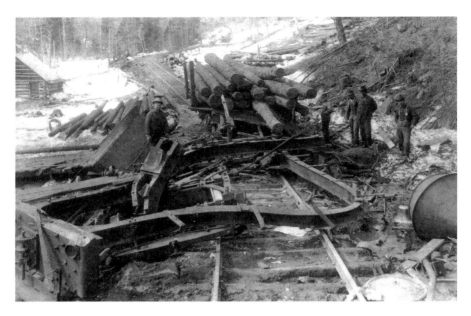

The explosion of the boiler on the Wild River Railroad's Shay No. 1 left three men dead, including engineer Henry Belmont. *From* Logging Railroads of New Hampshire's North Country *(2010)*.

February 12, 1900: G.W. Rowell, a brakeman on a train working the logging branch of the South Branch of the Israel River, was walking along the top of a loaded log car when he slipped and fell as the train was moving. Unfortunately, he slid right under the moving train and was killed instantly when he was run over.

January 5, 1904: Brakeman Fred Stuart, also working on the South Branch of the Israel River, was helping to hitch up some loaded freight cars at the junction of the South Branch and Bowman lines when he apparently fell under the wheels of the moving train and saw his right leg and thigh severed through in three places. Though he initially survived the incident, he died later that same night in Whitefield.

Chapter 8

Big Blow: The Hurricane of 1938

Whenever a hurricane forms in the Atlantic Ocean and early storm tracks indicate that the northeastern United States may be targeted by the tropical system, one can't but help think back to a historic event that occurred some seventy-five years ago. That's when the great "Hurricane of 1938" blew through New England and devastated large areas of New Hampshire's forestland that are today the playground of many hikers and outdoor recreation enthusiasts.

This unanticipated storm, which wreaked havoc across Long Island and coastal New England, is still considered one of the nation's worst natural disasters. The September 21, 1938 storm caused hundreds of millions of dollars in damages, destroyed an untold number of homes and businesses, killed close to seven hundred people and injured two thousand more, and forever changed the landscape of northern New England, where between 1 and 2 billion board feet of merchantable timber were leveled by the hurricane's tremendous winds.

Though the Granite State was spared the widespread destruction encountered elsewhere in New England—especially in places like Providence, Rhode Island, and New London, Connecticut—it was still a huge force to be reckoned with, and many old-timers who I've talked to in recent years still marvel at the fury of the hurricane that they got to witness firsthand. One such person was the late Winston Harris of Whitefield, New Hampshire, who I interviewed several years ago at his home on Kimball Hill Road.

Just twenty years old in that fall of 1938, Harris was working at the Appalachian Mountain Club's Pinkham Notch Camp just south of Gorham when the storm reached the northern part of the state after weaving its path of destruction through southern New England earlier in the day. Harris recalled that it had rained heavily for a couple of days prior to September 21 and that water had begun to flood the basement of the AMC camp situated at the eastern base of Mount Washington. Harris said he was about to drive a short distance north to a nearby CCC camp, where he hoped to secure a desperately needed water pump, when the storm struck Pinkham Notch with an intensity he'd never experienced before or since.

"Out on the [cabin] porch…we just wrapped our arms around the support posts" for fear of getting blown away, he said. The wood furniture on the porch was no match for the gusty winds, as pieces "went off that porch like a bunch of paper bags, right out into the woods, and we hung onto them posts for dear life. I thought it was going to suck us right off into the woods." It was just about then that Harris and his fellow AMC employees knew something unusual was happening. "We were used to the high winds up on the mountain, but not down here in the valley. We knew it was something weird here."

Harris recalled that earlier in the evening, at about 5:00 p.m., one of the summit employees of the Mount Washington Observatory tried to drive up the mountain on the Auto Road, even though the weather was stormy and getting worse by the minute. "We tried to discourage him from going because we didn't know how much the [auto] road was washed out. He only got a mile or so up when trees started coming down in all directions, so he decided then he'd forget about getting to the summit and would instead drive back to the AMC camp," recalled Harris. By then, the storm was really picking up in intensity, and if not for the fact that the man was equipped with an axe and an old saw, he would never have been able to navigate his way through the maze of downed trees that soon littered the Pinkham Notch highway between Jackson and Gorham.

As newspapers of the day reveal, the hurricane did more than its fair share of damage in certain pockets of New Hampshire. Among those areas hardest hit were the Keene and Monadnock Region, Weare and much of the White Mountain region in the northern part of the Granite State.

"North Country people arose this morning to survey untold damage, and tired workmen continued their all-night labors to clear highways and establish communication with the outside world, following the worst hurricane to hit this section in the memory of the oldest residents," began

Celebrating the Region's Historic Past

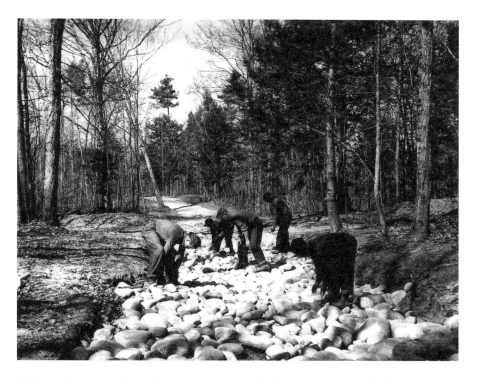

CCC enrollees from Camp Thornton repair a washed-out road damaged by floodwaters from the nearby Mad River. *White Mountain National Forest Archives.*

the *Littleton Courier* newspaper in its report on the hurricane. The paper went on to say that both Franconia and Crawford Notches had been closed due to flooding and blocked road surfaces, while elsewhere in the area, a footbridge over the Ammonoosuc River had washed away, the scenic Glessner Woods in neighboring Bethlehem were practically leveled by the storm's ferocious winds and residents of Manns Hill "took some five hours this morning to make the trip to Littleton village, as they had to chop their way through numberless fallen trees."

In nearby Sugar Hill, reported the newspaper, the hurricane lifted the roof off the garage at the Hotel Lookoff, damaging several cars, and the roof on the main hotel building also sustained damage. Likewise, at the Sunset Hill House, a portion of the roof and the hotel's chimney "were demolished," and a "beautiful maple grove…was laid low at Peckett's Inn," where more than eighty guests also found themselves without any water after the storm put the hotel's system out of commission.

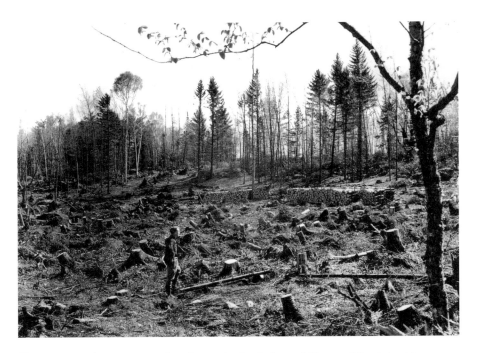

Cleanup operations appear well underway in the decimated Glessner Woods tract in Bethlehem. *White Mountain National Forest Archives.*

Flooding from the great Hurricane of 1938 not only changed the course of Flume Gorge Brook in Franconia Notch but also buried the first Flume Gorge bridge under a pile of boulders. *Author's collection.*

Lincoln, just south of Franconia Notch, was the scene of much devastation, according to the town's local news correspondent. "Looking over the town, one sees nothing but destruction," reported the Littleton newspaper. "Hundreds of trees fell in the main part of town, taking with them wires, telephone poles, clothes lines, and doing considerable damage to many of the houses." An old town character who was watching the large group of lumberjacks hired by Parker-Young Company, owners of a longstanding paper mill, quipped that this was the first time in more than forty years that logging was taking place in the village itself.

Just north of Lincoln village, at the Flume Gorge, "last week's storm devastated hundreds of acres of beautiful forest," reported C.T. Bodwell, director of the Flume Reservation. "The Sentinel Pine, estimated to be about 275 years old and perhaps the largest pine in New Hampshire, was blown down, as well as a large strip of virgin white pine and red spruce. In many areas, it will take 100 to 150 years to reproduce the fine stands of timber and forest trees demolished in less than two hours."

For two Littleton area men who were fishing at Beaver Lake in Kinsman Notch when the storm struck, it took hours to get back home, as flood-swollen streams and rivers washed out numerous local roads. First alerted to the impending flooding situation by men from one of the nearby CCC camps, Gene Allard and Ephraim Corey attempted to drive home by way of Franconia Notch but had gone only a short distance when they encountered their first road washout, which forced them to abandon their vehicle and begin "hoofing it" toward North Woodstock village. Over the next several hours, they encountered more washouts and, in several instances, had to make their way through swollen streams that were neck high with floodwaters.

A ride from Lincoln village to the area near the Indian Head profile south of Franconia Notch also ended abruptly when a small landslide blocked the highway. "The pair took to the road again and hiked up to the [Cannon Mountain] tramway," where they managed to hitch a ride to Littleton with a gracious northbound traveler. Ordinarily a twenty- to twenty-five-minute jaunt, the last twelve-mile leg of their journey took nearly three hours to complete, as they were diverted by circumstances to Sugar Hill and Lisbon. In total, the men needed nine hours to traverse the twenty-five miles or so from Kinsman Notch to Littleton.

Few areas in or near the mountains escaped the hurricane's wrath, as excess wind and water wreaked havoc not only in the White Mountains proper but also in central New Hampshire, the southern Whites and along the upper Connecticut River valley.

"In Plymouth, the worst of the storm came after 7 o'clock. Many of the big elms on Main Street were reported uprooted, including several on the Common. There is not a street in town...which escaped," reported the *Bristol Enterprise* newspaper. Meanwhile, over in North Haverhill, along the Connecticut River, "at the county farm...19 cows were stranded on an island between the main river and the channel which flows near the buildings. So far is known, only three lost their lives."

Longtime Haverhill resident Bill Morse, writing about the hurricane many years later, recalled, "Trees and downed power lines barricaded the roads, making travel almost impossible, and as I recall, we were without power for three weeks. The most apparent impact that the storm had on the countryside was in the changed appearance of the surrounding horizon. Instead of the usual view of trees and woodlands, there was only a void—nothing but empty space." Falling victim to the big blow was a thirty-acre stand of merchantable pine that his father considered to be a prize family possession. "It was highly visible from our back doorstep. When we went outside the morning after the big wind, that stand of pine that had towered over the fields had vanished— uprooted and blown completely flat. It was unbelievable."

Among the storm's unfortunate human casualties was a Benton man, forty-four-year-old Roscoe Tewksbury, who died from a fractured skull when he was hit by a falling limb while clearing a road in the area of North Haverhill known as Horsemeadow. Also injured, but not as seriously, was C.M. Glover of Easton, who was struck by a wind-thrown barn door that caused him to break several ribs. Newspaper accounts also noted that a Lisbon woman was seriously injured when a piazza roof at her home on south Main Street collapsed because of the high winds at the height of the storm.

Because the track of the storm pushed it farther west as it progressed into northern New England, New Hampshire's North Country was spared the worst. Even so, the hurricane left its distinctive mark on the region, especially in the shire town of Lancaster, where dozens of stately elm trees were toppled by the storm's winds. The town's Main Street was called "a desolate spot" by the *Coos County Democrat*, which led its September 28, 1938 edition with a front-page story titled, "Making a Tour of a Near Treeless Town." The paper reported:

> Coos County, swept by the greatest wind in its history, was shaken and terrified, its trees leveled, its woodlots ruined and many homes left as if battle scarred. The miracle...was that not one fatality, not one serious accident, has been reported in the North Country in spite of thousands

Hurricane tree damage is quite evident along Long Pond Road in Benton. *White Mountain National Forest Archives.*

of trees uprooted and live wires carrying their added threats. Lancaster, its neighbor towns and all of Coos County may well dry their tears and look with sympathetic hearts towards those fellow men and women in dire distress in other sections.

Elaborating on the severity of the storm in the two best-known White Mountain "notches," the Littleton paper reported that three landslides blocked the highway in or near Franconia Notch, while at Crawford Notch, 150 persons were stranded because of blocked roads and crippled railroad service.

According to records from the Mount Washington Observatory, the strongest wind recorded atop New England's highest summit on the day of the storm was 163 miles per hour. Valley winds were, of course, substantially less than that but obviously still strong enough to knock over trees all throughout the region. While damage was relatively light at the summit of the Northeast's highest peak, the same could not be said for the western slopes of the mountain, where several new landslides were reported and a large section of the Cog Railway line, including the famous Jacob's Ladder, was blasted apart, with many of its ties strewn about in nearby

Workers clear up a landslide near the Old Man viewing area in Franconia Notch. *Author's collection.*

Burt's Ravine. "It was all twisted up," recalled Winston Harris. "I never went to see it myself, but the boys brought down some pictures. You couldn't believe that you could twist that big stuff up like a haywire." Remarkably, the Cog was able to rebuild some 2,500 feet of ruined track and trestlework in a little more than a month's time, and it was fully operational the next spring.

The biggest victim of the Hurricane of 1938 was New Hampshire's vast forestland, which took a huge hit with an estimated 1.5 billion board feet of timber being destroyed. State forest officials estimated in 1940 that about 110,000 acres of the White Mountain National Forest sustained such serious damage that they were classified as areas of high fire hazard. This led to the closure of thousands of acres of WMNF land in the Pemigewasset Wilderness and on the slopes of Mount Osceola near Waterville Valley and the strict enforcement and patrolling of the woodlands in both areas. "Trees on the upper south side of Osceola were flattened, and the scars were visible for many years," recalled Waterville Valley historian Grace H. Bean in 1983.

Along with the stand of virgin timber near the Flume Gorge that was leveled by the storm's destructive winds, a large, old-growth stand in the bowl separating Mounts Field and Tom near Crawford Notch was laid to

Due to the extreme damage caused by the hurricane and the potential for forest fires, signs like the one were posted at trailheads throughout the White Mountain National Forest. *White Mountain National Forest Archives.*

waste, as was a good part of a similar old-growth stand in the Nancy Brook valley a little south of Crawford Notch. Another victim of the storm was the year-old auto road up Mount Willard, which sustained heavy washouts and was never reopened.

A host of hiking trails all across the Whites were similarly impacted by the storm. Among those either lost for good or closed for a number of years were: the Bread Tray Ridge Trail up Osceola—a path that also snaked its way through a fine old-growth stand; the section of the former North

Twin Loop Trail that directly linked the summit of North Twin to the Gale River valley and the former Galehead Trail; the less-than-a-year-old Nancy Pond Trail from Notchland up Nancy Brook to remote Nancy and Norcross Ponds; the Tunnel Ravine Trail, which ran from the Tunnel Brook valley to the summit ridge of Mount Moosilauke by way of a Dartmouth Outing Club shelter; the southern end of the Franconia Ridge Trail, which back in 1938 extended south from the summit of Mount Flume all the way to Lincoln and the East Branch of the Pemigewasset River.

In the two years following the great hurricane, an unprecedented timber-salvage operation was undertaken by the state and federal governments. This work resulted not only in the reopening of several closed CCC camps throughout New Hampshire, but it also gave much-needed employment to citizens still being adversely affected by the decade-long Great Depression. Private industry also received a boost from the hurricane cleanup, as was evident in the Conway area, where more than 4 million board feet of timber was cut in the area and stored in Pequawket Pond for eventual processing. "Many woodsmen got good pay for their skilled work, and some $60,000 circulated in Conway as a direct result of the hurricane," reads a 1998 history of the town.

The New Hampshire Forestry Commission, in its biennial report for the years 1939 and 1940, noted that in the two years following the hurricane, over 402 million board feet of logs, mostly pine, were delivered to about 530 government receiving sites in the state by nearly 600 different forest owners, for which they were paid $4,656,953. Some 29,000 cords of pulpwood were also sold to the government. Another 2 million feet of timber, exclusive of pulpwood, was also cut by private owners but not sold to the government. In total, lumber production for the year 1939 ended up close to the same yield that occurred in 1907, during the era of logging railroads in the Granite State. The 1907 yield was the highest ever recorded in New Hampshire.

Due to the increased risk of fire from downed timber caused by the hurricane, both the state and federal governments beefed up fire-detection services by either adding or reactivating mountain fire lookout towers. The U.S. Forest Service alone added a dozen White Mountain National Forest observation sites in 1939 and 1940, with new towers going up on Carr Mountain near Plymouth, Cherry Mountain in Carroll, Cooley Hill in Easton and Mount Garfield in Bethlehem, among other places.

As traumatic as the Hurricane of 1938 was to many Granite Staters, however, it could have been worse. As the *Bristol Enterprise* editorialized:

The Newfound Region is a stricken area. Our foliage friends have been slain, and many hearts are sad. Yet it is a fact that our uncounted losses are meager compared with the loss of life and destruction of property from the tidal wave, flood and hurricane in Rhode Island, and many other places. We have much to be thankful for.

OTHER NOTEWORTHY WEATHER EVENTS OF THE LAST ONE HUNDRED YEARS

Other than perhaps the annual summer plight of the Boston Red Sox, no topic seems to dominate northern New Hampshire conversations like that of the weather.

For good reason, folks in the White Mountains region and the state's Great North Woods frequently find themselves with an eye or two toward the sky, looking, listening and feeling for that next weather-maker that might bring with it rain, snow, sleet, hail and, on occasion, sunny, delightful conditions. At times, it seems as if we glory in our weather extremes, even as we grumble about the latest stretch of wet weather or find ourselves huddled next to a woodstove in an attempt to combat the latest winter cold snap.

As aforementioned, the Hurricane of 1938 was a landmark weather event in the Whites, but it is really just one of a number of significant, headline-grabbing meteorological occurrences that have taken place in the region over the past century or so.

Probably the second biggest weather event of the twentieth century was the catastrophic Flood of 1927, which took place on November 4 on the heels of two days of drenching rain that swelled local streams and rivers to record levels. Damage from the extensive flooding crippled many towns for days, with communities such as Littleton losing three of four bridges spanning the usually tame Ammonoosuc River. A Whitefield man, sixty-one-year-old William Harrington, was among the few area casualties of the floodwaters, as he was swept to his death by the raging Twin River at the western base of Mount Washington after unsuccessfully attempting to cross the torrent on an overhanging tree.

New Hampshire, the White Mountains and all of New England, for that matter, were also under water less than nine years later, when several days of heavy rain combined with the spring snow melt produced flooding up

and down the Granite State in the spring of 1936. In the northern half of the state, where more than twenty inches of rain fell in the Whites, the Plymouth-Campton region was hit especially hard by the flooding, while in Crawford Notch near the famed Frankenstein railroad trestle, slush and snow that slid off the nearby mountains blocked the state highway to a depth of some fifteen feet. It took a herculean effort by CCC workers to even open the road for one-way traffic. Elsewhere, ice jams blocked Route 18 between Littleton and St. Johnsbury, Vermont; boats were used to get around the flooded streets of downtown Berlin; and the snow level in Pinkham Notch dropped some two feet in a scant two days.

In late summer of 1954, the White Mountains region received a one-two punch from Mother Nature as the remnants of two hurricanes passed over northern New England in a span of just twelve days. Though Hurricanes Carol (August 31) and Edna (September 11) caused very little wind damage, they soaked the region with excessive amounts of rain, which in turn led to local flooding and scattered phone and power outages. Perhaps the most prominent reminder of these back-to-back storms was the great landslide that came crashing down the rain-soaked slopes of Mount Garfield and North Twin during Hurricane Carol. The slide, described as being 1,500 feet long and 30 feet deep, temporarily dammed up a branch of the Gale River. Unfortunately for hiker Ben Bowditch, a staffer at the Appalachian Mountain Club's Galehead Hut, the dam was breeched as he was walking on a trail that followed closely the course of the mountain stream. He managed to survive the flash flood caused by the breech but was then trapped on the trail between its first two river crossings, unable to proceed in either direction by the dangerously high flow. He did eventually make his way to safety, but not for another harrowing twelve hours.

Though not technically a hurricane, another late autumn storm, this one taking place four years earlier, on November 25 and 26, 1950, wreaked havoc throughout the Whites with its hurricane-force winds. In some areas, in fact, this gale caused more damage than the 1938 hurricane. The weekend storm, with wind gusts exceeding 90 miles an hour, splintered and uprooted trees everywhere, including Littleton's Remich Park, where some three dozen stately old pine trees were toppled. In places like Bethlehem and Cannon Mountain in Franconia Notch, observers agreed that the damage exceeded that of the 1938 hurricane. Aerial Tramway manager Roland Peabody said it will never be known exactly how high the winds blew atop Cannon since the wind recorder at the summit went only as high as 90 miles per hour. A top wind of 160 miles per hour was reported on Mount Washington on the

twenty-sixth, while a sustained wind (of five minutes or more) of 120 miles per hour was also measured atop the Rock Pile.

Of course, high winds are typical atop Mount Washington, and none were greater than those recorded at the summit on a memorable afternoon in April 1934, when a world-record gust of 231 miles per hour was recorded and witnessed by staff members of the Mount Washington Observatory. The April 12, 1934 event forever cemented Mount Washington's well-deserved reputation as being home to the "world's worst weather."

The White Mountains have also experienced some memorable winters over the years, with the 1968–69 season the standard by which all winters are now compared. During an incredible six-month period beginning in November 1968 and extending through April of the following year, 536 inches of snow fell on Mount Washington, and the snowmobile season lasted well into April, with trails in the Zealand and East Branch Valleys harboring a good two feet of snow more than a month after the official start of spring. The biggest event of that winter was a late February storm that lasted for three days and dropped 91 inches of snow on Mount Washington, including a record 49.7 inches that accumulated in a single day (February 25, 1969). The same storm dumped 76 inches of snow on the Appalachian Mountain Club's Pinkham Notch camp, where by the end of February, recalled AMC huts manager Bruce Sloat, "the snow got up as high as the midpoint of the second story windows."

In February 1978, the much-written-about New England Blizzard of 1978 also left its mark on the region, with as much as four feet of snow falling on some parts of the Whites. Area snow totals for the event saw Twin Mountain receive thirty-two inches, Franconia Notch thirty-six inches, Pinkham Notch forty-one and Crawford Notch a remarkable fifty inches.

Perhaps the most unusual dose of weather and other naturally occurring events of the twentieth century took place in January 1943, when within a week's time, the area was hit with two small earthquakes, a six-inch snowfall and a mid-winter windstorm with gusts of 50 to 60 miles per hour. The quakes, centered about 125 miles apart, were felt in all six New England states, but no damage was reported locally. The windstorm "howled so that many citizens were unable to sleep," reported the *Littleton Courier* in its January 21, 1943 edition. The windy weather also brought in a mass of arctic air from Canada that resulted in rapidly plummeting temperatures. "The cold coupled with the stinging gales practically paralyzed all motor and pedestrian travel," noted the paper. At Cannon Mountain, the wind was so severe that the five-year-old Tramway was unable to move for two days

because of the gales, while the overnight temperature dropped to minus-twenty at the summit station.

Later that same year, a whopper of a snowstorm struck the North Country a few days before the Thanksgiving holiday. The unusually early winter storm buried the Pinkham Notch area in a record fifty-one inches of snow, while upwards of three feet of snow blanketed many other northern New Hampshire localities, including Bethlehem and Franconia Notch. Oddly, the village of Lincoln, just a short distance south of Cannon Mountain and Franconia Notch but about one thousand feet lower in elevation, received just a few inches of snow in the four-day storm. Because of the heavy snow, many holiday visitors resorted to horses and sleighs to get around towns like Sugar Hill, where twenty-eight inches of snow fell. In Bethlehem, one resident told the local newspaper it looked like a scene from "forty years ago," as many horse-drawn vehicles were observed making their way along the town's Main Street.

Other events of note in more recent years include the January 1998 ice storm that blanketed many sections of the White Mountains with a coating of thick ice that did not melt for more than a month. Weighted down by the ice, many trees and branches were toppled, especially in and around Randolph and Crawford Notch. The result was that many hiking trails were blocked by the downed trees, and it wasn't until that summer that all trails were reopened to foot traffic.

Tropical Storm Irene, which passed through the region in late August 2011, was another devastating weather event. In this case, it wasn't so much the wind that caused problems, but the drenching rain that accompanied the tropical event. Besides causing widespread damage to area highways and some bridges, the storm heavily impacted the region's trail system, with more than forty footpaths receiving moderate to heavy damage. At this writing, several hiking trails and access roads within the White Mountain National Forest remain closed due to storm-related damage.

Chapter 9

Plane Crash in the Pemi: The Tragic Tale of the Missing Doctors

A wire-service story appearing in newspapers all across the Northeast back in February 1959 brought to the forefront the fascinating and tragic story known in our neck of the woods as the "Tale of the Missing Doctors." If you read the Associated Press piece, then pardon me for rehashing the tale again. For those unfamiliar with the story, however, it's a tale well worth repeating.

The so-called missing doctors were sixty-year-old pathologist and airplane pilot Ralph Miller and thirty-two-year-old heart and lung specialist Robert Quinn, both of whom were affiliated with Dartmouth Medical School and were physicians on the staff at Mary Hitchcock Hospital in Hanover. In the middle of the winter, more than fifty-four years ago, the two flew from Hanover to Berlin for an emergency medical call. But on their return trip on a cold and stormy February day, the small Piper Comanche plane piloted by Miller crashed in the remote Pemigewasset Wilderness about a dozen miles north of Lincoln.

The resulting search for the doctors, who miraculously survived the crash but ultimately could not survive the elements, was considered at the time one of the biggest (if not *the* biggest) such efforts ever undertaken in northern New England. For eight agonizing days, dozens of planes and helicopters—both private and military—scoured the White Mountains and Upper Connecticut River Valley regions in the hope that the downed plane would be spotted from above. But with little to go on other than the general direction in which the plane was headed, it was like looking for the proverbial needle in a haystack, complicated even further by the fact that the

plane was mostly white in color, with a bit of red trim, and would be almost impossible to spot from the air with the ground below well blanketed in snow.

The plane with the two doctors aboard had left the Berlin airport at about 3:30 p.m. on Saturday, February 21, 1959, with several locals saying they saw the plane leaving the area and heading south as light to moderate snow was falling. The last definite sighting was shortly before 4:00 p.m. as the plane flew past the former Tower Inn in Jefferson. From that point on, the plane's exact route is unknown, as it was not seen again in flight.

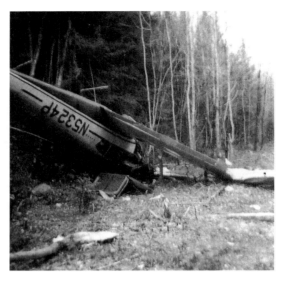

The doctors' plane was found flipped over and lying partly in the woods, just off the grade of the former East Branch & Lincoln logging railroad line. *Author's collection.*

Published reports at the time said that it became apparent during the evening hours of February 21 that something had gone wrong with the doctor's plane, as it failed to arrive in Lebanon as planned. Both doctors' wives started making concerned calls, and this prompted a Lebanon Airport official to contact Whitefield Municipal Airport operators Shirley and Dick Mahn to see if, by chance, Dr. Miller had abandoned his flight plans and had landed instead at the airport not far from the rugged peaks of the Presidential Range. The Lebanon airport official told the Mahns that normally when Dr. Miller was forced to scrap his flight plans and was going to spend a night away from home, he always phoned ahead to his wife and the airport.

North Country–based pilot and educator Richard Pinette, writing about the subsequent search for the missing doctors in his 1986 book *Northwoods Echoes*, recalled arriving at the Berlin airport in Milan the morning after the doctors' plane went missing. It was a bitter cold day, wrote Pinette, with the temperature several degrees below zero, but local members of the Civil Air Patrol were ready to do their part in searching for the presumed downed plane. "The engines on several of the aircraft were so stiff from the cold oil that one could almost chin himself up on the propellers when trying to turn

them over by hand to break the cold seal," wrote Pinette. "A stiff wind made low flying especially hazardous and difficult over the mountain ridges. Frost formed on all of the side windows of the search planes, restricting visibility, but the pilots continued to fly one sortie after another."

The doctors couldn't have picked a worse time to crash given that the White Mountains were in the midst of the coldest temperatures of the winter. For three consecutive nights just after the crash, overnight temperatures plummeted to between twenty and thirty below zero. Still, there was hope that if Miller and Quinn had survived any crash, they would have been able to survive, especially given that Dr. Miller had an extensive outdoors background and was well versed in survival skills.

Despite the frigid mid-winter conditions, the *Littleton Courier* newspaper reported on February 26 that more than three hundred men had taken part in various ground searches in the first five days after the plane went missing. That number was probably a low estimate, however, as other published reports put the number at well over five hundred. Among these searchers was a large contingent of members from the Dartmouth Outing Club, with whom Dr. Miller, a 1924 Dartmouth College graduate, was closely affiliated. DOC members Sam Adams, son of former New Hampshire governor Sherman Adams, and Jim Baum coordinated the club's involvement in the search effort, with Baum remembering that "many students simply quit school while this effort was going on." Also among the student searchers was Dr. Miller's son, Ralph Jr., a former U.S. Olympic team skier who at the time was a second-year Dartmouth medical student and an active DOC member.

The Littleton paper noted that on several occasions in the days just after the plane was reported missing, search officials contended with numerous false sightings of the downed aircraft, with reports coming in from Gilman, Vermont; nearby Littleton; and Cherry Mountain in the town of Carroll, New Hampshire. The Littleton report appears to have been the most credible of the lot, as a local resident claimed she saw a plane fitting the description of the missing aircraft on the day of its disappearance. On February 22, the day after the plane went down, a ground search involving nearly two dozen DOC members was undertaken in the area near the former Lewis Airport in the Apthorp section of Littleton. The effort, of course, turned up no plane.

For eight intensive days, the search for the two physicians went on, but on the ninth day, Governor Wesley Powell decided to call off the effort, figuring that by now the doctors, if they'd even survived the crash, would have succumbed to the bitter cold and snowy conditions that still enveloped northern New England. While official search efforts were discontinued,

unofficial search efforts went on, with Dartmouth College funding some of these efforts and the U.S. military taking an active part as well.

But it wasn't until May 5, more than two months later, when much of the winter snow had melted, that the downed plane was finally spotted from above by pilot Richard Stone of Newport, New Hampshire, and his passenger, New Hampshire Fish and Game conservation officer Ernest Melendy of Franklin. A day later, ground crews made the long trek up the East Branch valley of the Pemi to the crash site and there found the plane flipped upside down along the edge of an old logging railroad bed (then part of the Thoreau Falls hiking trail), with its two deceased occupants in proximity to the aircraft.

What shocked the ground crews most, however, was the discovery that Drs. Quinn and Miller had indeed survived the actual crash and had lived for several days afterward, having tried to start a small campfire next to the plane and also managing to fashion homemade snowshoes out of saplings, surgical tape and pieces of cord. According to a series of notes written by the doctors and discovered along with the wreckage of the plane, the physicians were unsure of their whereabouts and knew the weather was not conducive for a successful air search. One valiant attempt was made by the men to walk out to safety on their homemade snowshoes, but as Miller wrote the day after the plane went down, "we went south...but the road petered out, and we returned with enough energy to secure wood for the night."

Two days later, with little chance for survival, Miller wrote, "Still trying though tools broken. No hope left...Goodbye all."

What makes this story all the more tragic is the fact that Drs. Miller and Quinn, though unbeknownst to them, were a relatively short distance from safety when they abandoned their Sunday, February 22 snowshoe trek when it appeared that the road they were following "petered out." If they'd continued just another one hundred yards or so, they would have regained the old logging railroad grade, and in another eight-tenths of a mile would have come across the U.S. Forest Service's former North Fork Cabin, which was outfitted with a stove, blanket and food. The spot where they'd thought the road had ended was actually the former site of a train trestle. Had they successfully negotiated the ravine that was once bridged by the trestle, survival would have been well within their reach.

It was also learned after the fact that the radio in the plane was still operational after the crash, but because the plane was nestled in a valley surrounded by peaks of more than four thousand feet in elevation, any messages sent from the radio were effectively blocked by the terrain. Only a

Celebrating the Region's Historic Past

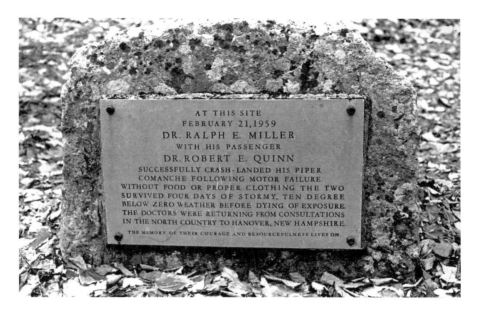

A monument along an abandoned section of the Thoreau Falls hiking trail marks the spot of the doctors' fatal plane crash. *Photo by author.*

plane flying overhead would have been able to hear any messages sent from the radio.

In the aftermath of the plane's discovery and the recovery of the doctors' bodies, it was determined by investigators that the crash was probably caused by a lack of fuel in the plane, and not icing, as Dr. Miller had surmised in the notes he left behind. It is thought by some that due to the poor flying conditions, Dr. Miller had decided to forego the ride back to Lebanon and had actually turned his plane around and might have been headed back toward Whitefield Municipal Airport when his low-flying Piper Comanche ran low on fuel and crashed in the heart of the Pemi Wilderness.

Reflecting on the incident many years later, Philip Nice, a pathology department colleague of Ralph Miller and an active participant in the search for the missing doctors, told *Dartmouth Medicine Magazine* that things might have turned out differently if an immediate aerial night search had been undertaken as soon as authorities learned that the plane had disappeared. That night, he said, there was a brief break in the weather, and a flyover of the Pemi Wilderness might have detected the fire that the doctors had started that first night.

Nice also believes the massive search for Miller and Quinn was not very well organized or effective. "The search efforts were intense but chaotic due to too many units trying to be helpful, with no central organization to coordinate efforts," said Nice. The vast number of well-intentioned false sightings also detracted from search efforts, he believes, as they stretched resources far beyond the realistic location of the downed plane.

Although the doctors' plane crash is well remembered by locals, few hikers headed today into the popular Pemi Wilderness know about the incident, and only a tiny percentage bother to visit the actual crash site, despite the fact that a marker was erected at the site years ago. That's because the stretch of old railroad grade where the plane went down is no longer a part of the Thoreau Falls Trail, which several decades ago was rerouted onto the east side of the East Branch to eliminate two potentially dangerous stream crossings.

The best reminders of the "Missing Doctors" ordeal are those preserved in print, such as Pinette's recounting of the story in *Northwoods Echoes*, author Floyd Ramsey's retelling of the tragedy in his best-selling book *Shrouded Memories: True Stories from the White Mountains of New Hampshire* and David O Hooke's short excerpt in *Reaching That Peak: 75 Years of the Dartmouth Outing Club*, published in 1987.

Bomber Crash of 1942 Still Stirs Plenty of Interest

When area history buffs bring up the topic of the doctors' missing plane, the conversation invariably switches over at some point to another memorable crash that will be forever linked to the Lincoln-Woodstock area. This event took place during the early months of World War II, and even though more than seventy years have passed since its occurrence, interest in one of New Hampshire's most memorable events from that time period remains exceptionally high.

It was on a cold and snowy night in January 1942 when a B-18A bomber assigned to Westover Field in Chicopee Falls, Massachusetts, veered sharply off course and slammed into the side of Mount Waternomee, a spur peak of 4,800-foot Mount Moosilauke. The bomber, piloted by First Lieutenant Anthony Benvenuto of Brooklyn, New York, and co-piloted by Second Lieutenant Woodrow "Woody" Kantner of Crawford, New Jersey, had set

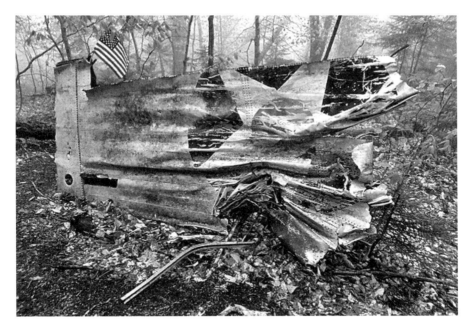

Wreckage from the January 1942 bomber crash still litters the woods on the upper slopes of Mount Waternomee in Woodstock. *Photo by Steven D. Smith.*

out earlier in the day from Westover with instructions to patrol the Atlantic Ocean coastline for German submarine activity.

On the plane's return trip to the western Massachusetts air base, shifting winds and blinding snow squalls forced it off its intended route. Unbeknownst to the crew, the plane was headed north toward the mountains of northern New Hampshire and not its home base in the broad Connecticut River valley near Springfield, Massachusetts. Forced to fly at a lower elevation than usual due to a worsening icing problem, the plane eventually crashed into the mountainside overlooking the Pemigewasset River valley near Woodstock and Lincoln. Splitting into several pieces, the bomber came to rest in the deep snow after shearing off numerous tree tops. Two subsequent explosions caused by leaking high-octane fuel further demolished the plane but also alerted members in the neighboring Pemi Valley communities to the early evening crash.

Within minutes, a nightlong rescue operation involving state and federal authorities and many local volunteers (including woodsmen and future Granite State governor Sherman Adams) was set into motion, and much to the amazement of most everyone involved in the effort, five of the bomber's seven crew members were found alive, though injured and

quite shaken from the ordeal. Among the survivors were the two pilots—Benvenuto and Kantner—plus navigator Second Lieutenant Fletcher Craig of Gridley, California, machine gunner Private First Class Robert Picard of Springfield, Massachusetts; and aircraft mechanic Private Richard Chubb of North Billerica, Massachusetts. Dying in the crash were Private Raymond Lawrence of Worcester, Massachusetts, and Noah Phillips of Fayetteville, Arkansas, both apparently victims of one of the post-crash explosions, as their charred bodies were found in a section of the plane that had been blown away from the fuselage by the one of the blasts.

Rather than fade from memory, the tragic 1942 bomber crash continues to fascinate people, and none more so than the residents of Lincoln and Woodstock, who several years ago turned out one hundred strong for a program related to the crash site as it exists today. Presented by Dr. Victoria Bunker, who in September 2006 conducted an archaeological study of the site for the U.S. Forest Service, the program featured dozens of "now-and-then" photographs, showing the site not only as it existed in the fall of 2006 but also as it appeared in the immediate aftermath of the actual crash.

Besides enjoying the photo presentation, the many people attending the program also got to take an up-close look at pieces of wreckage salvaged over the years by local treasure hunters and now a part of the local historical society's permanent collection of memorabilia. Some of these pieces were no doubt carted down off Mount Waternomee by North Woodstock's Charlie Harrington, a retired barber, history buff and vintage aircraft fan who is also considered the local "expert" on the bomber crash.

Back in 1981, Harrington had the honor of guiding one of the crash survivors—Woody Kantner—up to the crash site when the co-pilot returned to the North Woodstock area a few months shy of the fortieth anniversary of the accident. The two were reunited eleven years later when a fiftieth anniversary commemorative observance was held over the Fourth of July weekend in 1992. Also attending that event was crash survivor Richard Chubb, plus several members of the rescue team that braved the elements and helped bring the living victims down off the mountain.

Perhaps no one has helped to keep the events of January 1942 more alive than Floyd W. Ramsey of Littleton, a retired teacher and Lincoln native who was just a kid when the B-18 went down. During the 1980s and 1990s, while contributing a series of articles for the now-defunct magazine *Magnetic North*, it was Ramsey who pieced together the story in "The Night the Bomber Crashed," which is considered the definitive work on the crash of the B-18 and the dramatic rescue of its crewmen. Ramsey's account, which was subsequently republished

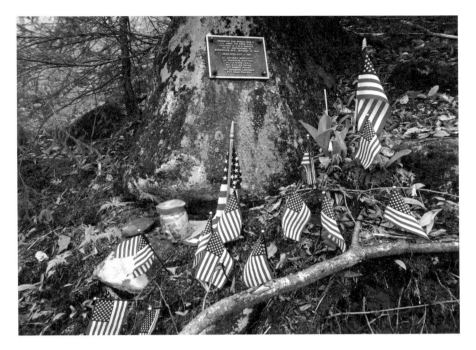

A flag memorial and plaque mark the site where the B-18 bomber went down during a January snowstorm in 1942. *Photo by Steven D. Smith.*

in the *New Hampshire Sunday News* and dramatized on one of Fritz Wetherbee's *New Hampshire Crossroads* pieces that aired on New Hampshire Public Television, was later included in his self-published book, *Shrouded Memories*, while a separate booklet featuring just the bomber crash tale was republished a few years back by Littleton-based Bondcliff Books. Both *Shrouded Memories* and "The Night the Bomber Crashed" remain popular local bestsellers.

While there is no official trail or path to the crash site, a flagged route has been in existence for a decade or more, and each year, dozens of people manage to hike their way up the east-facing slopes of Mount Waternomee to the wreckage site. Here, pieces of the fuselage, the engines, the wings and other parts of the bomber lie scattered over an area of some 250 yards, much of it obviously overgrown after the passage of more than six decades.

For most who visit the site, it's like hiking back in time; a time, that is, when the horrors of World War II came awfully close to home in the White Mountains of New Hampshire.

Danger in the Air Over New Hampshire's White Mountains

Certainly, the January 1942 bomber crash on Mount Waternomee and the "Missing Doctors" crash of February 1959 are the most written-about plane mishaps in White Mountain annals. But there have been a number of other tragic high-profile incidents over the years that have also claimed lives of pilots and passengers alike. While many of these took place in the heart of the Whites, others occurred on the fringes of the region. Following is a chronological listing of some of the most noteworthy such events.

November 22, 1948: A small plane that had just taken off in drizzly, foggy weather from the airport in Whitefield crashed into the side of Cherry Mountain in Jefferson, claiming the lives of three Lexington, Massachusetts men who were flying home from a hunting trip to Pittsburg, New Hampshire. According to local news accounts, the plane was headed to Bedford, Massachusetts, but shortly after its 4:45 p.m. takeoff from the Whitefield airfield, it appears the pilot decided to turn the aircraft around, probably because of the poor flying conditions. Eyewitnesses in nearby Jefferson said the plane was flying at a low altitude and dropping flares, apparently in the hopes of finding a safe place to put the plane down in the early evening darkness. Instead, about thirty minutes after its initial takeoff, the plane crashed on the lower slopes of Cherry Mountain, about a half mile in from the closest road.

The wreckage of the four-passenger Stinson Voyageur aircraft was spotted the following morning by air, and rescue crews reached the downed plane later that morning, only to find all three of its occupants dead. Succumbing to injuries sustained in the crash were the pilot, thirty-eight-year-old automobile dealer Frederick A. Valente, and both his passengers: Buick Motors executive Donald W. Smith and Virgil Jennings. "The plane plowed a 20-foot path through the mountain shoulder, striking a 300-pound rock and finally coming to rest against a small maple tree," reported the *Coos County Democrat*. "The men were badly mangled and must have died instantaneously."

November 30, 1954: Northeast Airlines Flight 792, which originated in Laconia, was bound for Berlin, New Hampshire, when snow squalls in the eastern White Mountains reduced visibility to near zero. The twin-engine

Celebrating the Region's Historic Past

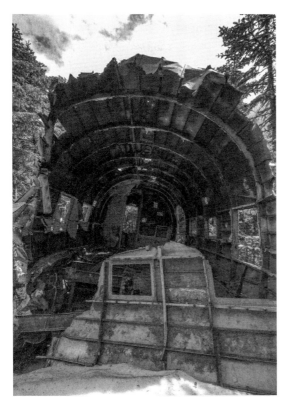

Left: A view inside the fuselage of the DC-3 that crashed on Mount Success in November 1954. *Photo by Chris Whiton.*

Below: Wreckage from the DC-3 lies amidst the heavily forested ridgeline of Mount Success. *Photo by John Compton.*

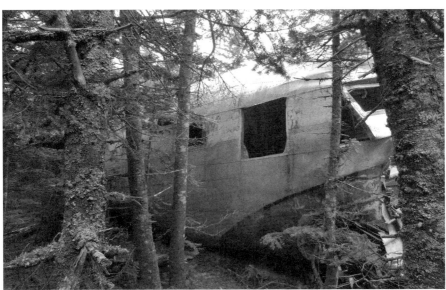

Douglas DC-3, piloted by Pete Carey, attempted to reach the Berlin Airport by instrument-only navigation, but as it neared Berlin—slightly off course and low on fuel—it crash-landed near the summit of 3,565-foot Mount Success, a significant peak along the rugged Mahoosuc Range not far from the Maine border.

If not for the heroic effort of Carey, who managed to avoid a head-on crash into the mountain with some last-second maneuvering, all seven people aboard the plane would have undoubtedly perished. Instead, Carey was able to belly-land the DC-3 in the dense forest of evergreens a short distance south of the mountain's south summit. He also managed to flip off all electrical power in the plane in the seconds prior to the crash landing, thus sparing the plane a potential explosion. Miraculously, Carey, his co-pilot George McCormick and the five others on board the place survived the crash landing, though two would eventually die from injuries sustained in the landing.

As the weather showed only marginal improvement over the next thirty-six hours, it would be nearly two full days before the wrecked plane was spotted from the air and rescue crews sent atop the mountain to aid the cold and weak surviving victims and recover the bodies of those who had died.

Remnants of the DC-3 still lie atop Mount Success, not far at all from the Appalachian Trail, which passes over the mountain. Sections of the plane found atop Mount Success include the main fuselage, the wings and the tail.

August 29, 1956: A small, three-passenger Stinson airplane crashed on Mount Lafayette in Franconia Notch, about 150 yards off the Old Bridle Path. J.O. Ashley, fifty-six, of Acushnet, Massachusetts, was piloting the plane at about 11:00 a.m. when he ran into dense fog as he approached the notch. When the mountain suddenly appeared in front of him, he took evasive action and crash-landed the aircraft in a clump of birch trees. Remarkably, neither Ashley nor his son was seriously injured. In fact, they walked away from the crash site, bushwhacked their way down to Route 3 in Franconia Notch and hitched a ride to their summer home in Jefferson without ever reporting the incident.

Two hikers on the Old Bridle Path actually witnessed the crash and, after making their way to the plane, were surprised to find it empty. In the meantime, campers at nearby Lafayette Campground also reported hearing the crash, and they immediately notified state park personnel. A search-and-rescue mission was then begun, even as the plane's occupants were being driven north to Jefferson. It wasn't until later in the day that authorities learned the crash victims were safe and nowhere near Franconia Notch. They learned this from a passing motorist who had stopped to give the pair a

ride earlier in the day but couldn't squeeze them into his full vehicle. Instead, the next car passing by picked up the crash victims and transported them north. It was on the first motorist's return trip through Franconia Notch, where he noticed a lot of unusual activity, that he decided to stop and tell authorities what he knew from talking to Ashley earlier.

While relieved to learn that no one was killed in the crash, authorities were not at all happy that Ashley opted not to report the incident and that he'd left the scene. Ashley's explanation for not calling in the crash was that he did not want to alarm his wife.

March 19, 1966: A single-engine plane piloted by a Creston, Iowa businessman crashed into Jennings Peak near Waterville Valley, killing the aircraft's lone occupant. The black-and-yellow Cessna, en route from Burlington, Vermont, to Portland, Maine, had last been seen on takeoff and was reported missing the following day after it failed to arrive in the Maine coastal city. Despite an intense weeklong search across northern New England, no evidence of its whereabouts was detected until more than six years later (June 24, 1972), when a hiker stumbled across the wreckage in a heavily wooded area near the 2,800-foot level on Jennings Peak. The crash victim was identified as Melvin Seymour, fifty-three, who was on the final leg of a business trip that originated in his home state.

October 25, 1968: Northeast Airlines Flight 946 from Boston, Massachusetts, to Montpelier, Vermont, crashed into the side of Moose Mountain near Lyme, New Hampshire, while approaching Lebanon Municipal Airport for a refueling stop. The Fairchild Hiller FH-227 aircraft, piloted by Captain John A. Rapsis, had just received landing instructions from the control tower at the Lebanon airport when it smashed into the mountainside, killing thirty-two of its forty-two occupants, including all three of the aircraft's flight crew.

Emergency personnel called to the scene of the crash were there within ninety minutes, and they helped treat ten survivors, who were then airlifted by helicopter to nearby Hanover and transported by ambulance to Mary Hitchcock Hospital. The bulk of the crash survivors were seated in the rear of the plane and managed to escape the wreckage by way of the rear emergency exit and through various fractures in the plane's fuselage. It was later determined that the plane's approach was about six hundred feet below its required altitude and that it was probably pilot error that caused the crash.

November 29, 1969: A single-engine Cessna 172 headed to Burlington, Vermont, from Portland, Maine, crashed into the upper slope of Oakes Gulf, a short distance due south of Mount Washington's summit cone. The small green-and-white aircraft, with three men aboard, was piloted by Kenneth Ward Jr., twenty-six, of Augusta, Maine. He and his two passengers—twenty-six-year-old Paul Ross of South Portland, Maine, and twenty-year-old Cliff Phillips of Island Pond, Vermont—were all killed.

Published reports state that the plane was first reported missing on Saturday the twenty-ninth, and that the crash probably occurred sometime around mid-morning that day. It wasn't until Tuesday, December 2, that the wreck was spotted on the mountain by WMTW-TV summit employee Lee Vincent, who saw the tail section "sticking up like an oversized trail sign" not far from the junction of the Davis Path and Camel Trail, on the southwest slope of Boott Spur. Other reports put the location of the crash near the Glen Boulder Trail at about 5,500 feet elevation.

The two passengers killed in the incident, both dressed in Santa Claus suits, were reportedly veteran parachutists who were scheduled to make promotional jumps that same day into shopping-center parking lots in Burlington and Bennington, Vermont, and Keene, New Hampshire.

March 20, 1971: A twin-engine plane crashed on Mount Washington near the seven-mile post on the Auto Road. Killed in the incident were Dr. Thomas Hennessey Jr., fifty-four, of Wellesley, Massachusetts, and his wife, forty-seven-year-old Irehne Hennessey. Weather observers at the summit said visibility was poor at the time of the crash due to fog and falling snow. The first indication that a plane had smashed into the mountain came when hikers climbing the mountain on Sunday, March 21, came across what appeared to be debris from a plane. Based on that report, U.S. Forest Service snow rangers began a limited search of their own and came across several other plane parts that had scattered across the mountain in high winds. A more extensive search of the area in and around Huntington Ravine was not possible that day due to limited visibility and a moderate to severe avalanche danger. It wasn't until midday on March 22 that searchers found the downed aircraft in what was described as a "relatively flat area" of Huntington Ravine not far from the Mount Washington Auto Road.

It was later determined that the plane's victims probably crashed into the mountain on Saturday, the twentieth, and not on the twenty-first, as originally thought. Early on the twentieth, they had flown from Massachusetts to Stratton Mountain in southern Vermont, where they left their thirteen-

year-old son with friends. They apparently continued on from there, but their destination was not known. Irehne Hennessey was a well-known model and television celebrity, serving for ten years as the "Hi Neighbor" girl for Narragansett Brewing Company commercials aired during Boston Red Sox telecasts. Her husband was an oral surgeon.

August 24, 1974: A married couple from Rancho Santa Fe, California, perished when their light plane crashed on the north slope of Mount Adams, not far above the Randolph Mountain Club's Gray Knob cabin and a short distance from the historic Lowe's Path hiking trail. At the time that the crash took place, there was extensive thunderstorm activity in the immediate area, and the high summits of the Presidential Range were enveloped in fog. The *Littleton Courier* reported that the plane had taken off from Whitefield Regional Airport at 3:45 p.m. after a brief refueling stop and was headed to Rockland, Maine. Shortly after takeoff, the plane's pilot, fifty-six-year-old Vernon Titcomb, radioed that he was canceling his flight plan and was going to return to Whitefield because of the stormy weather. The plane may have been making a left turn when a wing tip caught the shoulder of Mount Adams, causing it to crash and roll over several times. Two hikers were the first to spot the downed twin-engine Cessna 340 plane the following morning and immediately went down to the Appalachian Mountain Club's Madison Spring Hut to report their discovery. Killed instantly in the crash were Mr. Titcomb, described as a veteran pilot with more than twenty years of flying experience, and his wife, fifty-three-year-old Jean Titcomb.

August 2, 1982: A single-engine plane went down in a severe thunderstorm near Baldface Mountain in the eastern White Mountains and claimed the life of a Colorado man. A second occupant of the plane, twenty-two-year-old Rebecca Dufour of Portland, Maine, survived the crash and after wandering about in the woods for twenty-four hours made her way safely to Wild River Campground, where she reported the incident. Dufour told authorities that she survived the accident because she was thrown clear of the plane as it crashed. However, the pilot, twenty-eight-year-old Carl Arico of Boulder, Colorado, was trapped inside the cockpit and died when the Piper Comanche aircraft burst into flames shortly after it went down. It took searchers another two days to locate the plane and a third day to retrieve the badly burned body of Arico, who was in the New England area to attend the funeral of his father.

December 3, 1985: The pilot and a passenger of a small plane escaped serious injury when their Cessna hit a serious downdraft and crashed on the eastern slope of Mount Lafayette. The plane, bound for Lyndonville, Vermont, after taking off early in the morning from Portland, Maine, lost more than 4,000 feet in elevation when it hit the downdraft. It landed nose down on the forested slope of Mount Lafayette at about the 4,300-foot level. After crashing into the mountainside at about 10:00 a.m., the plane's pilot, Floyd Watts, fifty-five, of Rockland, Maine, was able to make radio contact with an Air Canada plane, and shortly thereafter, search and rescue efforts began. After a frigid five-hour wait, during which Watts and his fifty-year-old passenger, John Elliott of Brunswick, Maine, wrapped themselves in newspaper and carpeting to stave off bitterly cold conditions, the men were airlifted to safety by a U.S. Coast Guard helicopter. They were eventually taken by car to Littleton Hospital, treated for minor injuries and quickly released.

October 2, 1990: Three persons were killed when a single-engine Cessna attempting to pass over the Presidential Range en route from Syracuse, New York, to Bangor, Maine, scraped the lip of the Great Gulf just to the northwest of Mount Washington, causing a fuel tank to explode and the plane to crash about four hundred feet below the top of the craggy, glacial cirque.

Initially, no one was aware of the early morning (5:00 a.m.) explosion and resulting crash, save for a witness in nearby Jefferson who was looking out a window at his home when he saw an explosion of some kind in the direction of Jefferson Notch. It wasn't until two Vermont hikers reported to summit personnel atop Mount Washington that they'd discovered plane debris near the top of the Great Gulf headwall that anyone realized something was amiss.

Despite deteriorating conditions on the mountain, where the temperature had dropped below the freezing mark and winds were gusting to sixty miles per hour, a small team of searchers were dispatched to the area around the Great Gulf, and within two hours, they found a large debris field not far from the junction of the Gulfside and Westside Trails near Mount Clay. A short while later, the bodies of the three crash victims were discovered several hundred feet down into the Great Gulf. It wasn't until the following day that rescue crews were able to retrieve the bodies, but it was not an easy task, as ice and snow, combined with the steep nature of the terrain, necessitated the use of fixed climbing ropes.

December 24, 1996: A privately owned Learjet with two men aboard crashed into the north side of a hill near Smarts Mountain in Dorchester, New Hampshire, killing both occupants. The ensuing search for the downed plane, which was the largest land and air search in New Hampshire history, failed to locate the plane. It wasn't until November 1999 that the wreck was discovered by a semi-retired forester who was assessing woodland damage caused by a January 1998 ice storm. The crash site was not far from the Dartmouth Skiway.

The forty-foot-long Learjet, which took off from Bridgeport, Connecticut, and was en route to Lebanon Municipal Airport, was greeted with rainy, foggy conditions in the region and previous to its crash had attempted two unsuccessful landings at the airport. It is believed that the plane was headed south, back toward the airport, when the Christmas Eve crash took place at about 10:00 a.m. Dying in the incident were Johan Schwartz, thirty-one, of Westport, Connecticut, and Patrick Hayes, thirty, of Clinton, Connecticut.

Chapter 10

A Working Life Spent in the Woods

In the fall of 1999, I was commissioned by The Courier *newspaper of Littleton to produce a supplemental publication looking back at life in New Hampshire's North Country over the previous one hundred years. The following two chapters are revised and updated versions of profiles that appeared in this special millennium edition of the weekly paper. The following chapter looks at the life of the late Louis Derosia of Littleton, a longtime U.S. Forest Service worker who passed away in 2008 at the age of ninety-three.*

When Louis Derosia (then twenty years old) made the decision nearly eighty years ago to get off the farm and go into the woods, little did the North Haverhill, New Hampshire native realize that a whole new career lay ahead of him.

The year was 1935, and the nation was still mired in the Great Depression. Derosia, a recent graduate of Haverhill Academy, had been working on the Alphonse Fillion farm on Benton Flats since he was eleven, but now that he was a young adult, he knew it was time for a change. Job options were limited, needless to say, but enlisting in the two-year-old Civilian Conservation Corps (CCC) was certainly one viable option. Without telling his mother, Derosia signed up with the CCC and was assigned to the 134th Company stationed in nearby Warren.

The skills Derosia learned during what would become a three-year stint with the CCC would, in time, also lead to a fulltime career in the woods and a distinguished yet unspectacular career with the U.S. Forest Service. By the time Derosia retired from the Forest Service in 1970, he'd witnessed the

remarkable recovery of area forests from the devastating turn-of-the-century logging era and seen the White Mountain National Forest (WMNF) turn into a recreational mecca.

Now eighty-four years old and living in the same Littleton house he has called home for nearly fifty years, Derosia has only fond memories of his days as a WMNF ranger. "Over the years, I had plenty of opportunities for other jobs, but I liked the woods and loved being in them," said Derosia. "I guess that's why I stayed with the Forest Service."

His job responsibilities took him all over the forest, from the summit fire towers atop such peaks as Black Mountain in Benton and Cherry Mountain in Twin Mountain to the rugged logged-over peaks and valleys of the remote Lincoln Woods. Fighting forest fires, marking timber, searching for lost hikers and maintaining and repairing backcountry trails were among the many jobs he and other Forest Service workers routinely performed in those days.

Derosia got his first taste of forestry-related work while with the CCC in Warren, where he drove trucks, worked in the camp blacksmith shop and learned all about log scaling. This latter skill helped him get a job with the Forest Service once his CCC enlistment was up. Among his first jobs with the Forest Service was being sent to a timber sale near Sugarloaf Mountain in Benton, where he measured cut logs.

In the wake of the devastating Hurricane of September 1938, which leveled millions of board feet of timber across the White Mountains, Derosia found himself working for several summers in the East Branch country of the Pemigewasset River in Lincoln. Here, he patrolled the woods still being logged at the time by the Lincoln-based Parker-Young Company and served as part-time lookout on the short-lived fire tower atop Hancock Spur, a 3,900-foot peak high above the East Branch and Cedar Brook Valleys.

Based out of Camp 16, at the confluence of the East Branch and Black Brook, Derosia and his supervisor, Fred Gilman, patrolled a huge area of the forest, making sure hikers and other backcountry visitors kept the forestland fire-free. "Between the logging that had gone on and the hurricane, it was extremely hazardous in these woods," recalled Derosia in a November 1999 interview. "There was no camping allowed in the area because of the threat of a campfire getting out of control, so we had to patrol the trails every day to make sure everything was okay."

A typical patrol day for the rangers saw them covering fifteen miles of trail through valleys and over mountain ridges. Derosia's area included the North Fork, Shoal Pond, Zealand and Bond-Guyot regions. When he wasn't walking the trail, he could usually be found either up on Hancock Spur,

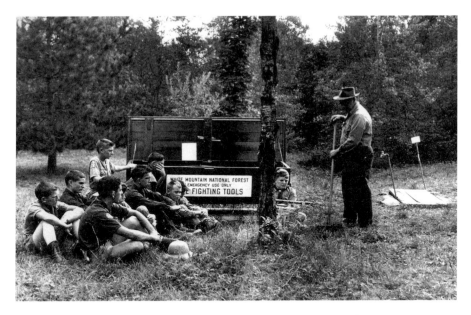

Longtime Forest Service employee Louis Derosia gives a group of Boy Scouts tips on prevention and suppression of forest fires. *Derosia family archives.*

watching for forest fires, or patrolling the logging railroad tracks still being used by Parker-Young locomotives. "We'd patrol behind them just in case a spark from the engine set some of the trackside slash on fire," said Derosia. Most of the time, these patrols were undertaken in speeders—trucks adapted for railroad track use.

Some of the worst fire offenders were the loggers themselves, and in particular one lumberjack who loved to light up a pipe out in the woods. "I knew what he was doing, but I could never seem to catch him. Every time he'd see me coming, he would hide the pipe in his pocket," recalled Derosia. "Finally, one day I snuck up on him and caught him in the act. I talked to him and then reported him to Billy 'The Bear' Boyle, the woods boss for Parker-Young. That night, when the last logging train headed back to Lincoln, the fellow with the pipe was on it, and he never came back."

Boyle, one of the most colorful loggers of his day, was one of Derosia's favorite woodsmen. Boyle was well known for his gruff manner, yet "for some reason, he took a liking to me," said Derosia. "Over time, we became very good friends."

While today's forest rangers are frequently called out to assist in mountain search-and-rescue missions, they were much more infrequent in the early

1940s. Derosia remembers his first "rescue" in the mountains, when a fellow Forest Service employee from Lisbon was seriously injured in a fall on remote Owl's Head Mountain in the Lincoln Brook drainage. "He was on a timber survey when he fell on the Owl's Head slide," recalled Derosia. "Because it was such a remote spot, it took quite a while to get a crew back in there, and when we tried carrying him out, we ran into some dangerous high water crossing Lincoln Brook. It was quite an ordeal. Unfortunately, the man still died."

After several years working in the Lincoln Woods, Derosia was transferred to the Warren area for a nine-year span covering most of the 1940s. From there, he maintained the phone lines to fire lookouts atop Black Mountain in Benton and Carr Mountain in Rumney, marked and scaled timber and did his share of time atop Black Mountain, where in 1948 and 1949, he was the chief fire lookout.

"It could get pretty lonely up on the tower all by yourself, but I loved it up there," said Derosia. "I wasn't a very good lookout—I only spotted a couple of fires, and they both happened to be burning on the same day, in Bath and Lisbon." He said his predecessor on the mountain, Maude Whitcomb, one of the first women fire lookouts, "did a lot better job than I did. If she saw any smoke at all, she'd call it in. I wouldn't always do that."

Visitors to the mountaintop tower, which was originally established by the state, were infrequent and were mainly groups of kids from area summer camps. Because the lookout perch was so small—about fourteen feet by fourteen feet—only a half dozen people at a time were allowed in the tower. Derosia said he got used to and enjoyed the solitude of the summit and often found it difficult to go home to his growing family, which by then included four young and restless kids. "I'd go home to all the jumping and screaming kids, and I'd have a fit," he joked. "I knew I wasn't on the mountain anymore."

Eventually, Derosia was transferred to Littleton, where the Forest Service maintained an administrative office in the federal post-office building on Main Street. As assistant ranger in the Ammonoosuc Ranger District, he performed a lot of work related to pending timber sales. His job responsibilities over the ensuing years also found him supervising Forest Service campgrounds at Sugarloaf, Zealand and Gale River; performing trail maintenance on many of the paths on the western slopes of the Presidential Range; and working the occasional shift on fire towers atop Mount Hale in Bethlehem and Cherry Mountain.

As he neared retirement age, Derosia said things had changed substantially on the forest and in the way rangers performed their jobs. By 1960, for instance, forest fire lookouts were an endangered species in the Whites, as

Celebrating the Region's Historic Past

airplane patrols had replaced the resident fire watchers. By this time, Derosia said tower lookouts were also hampered in their efforts by the increasing amount of haze and smog in the air, which at times drastically limited visibility. There was also less danger of fire, since the forest had begun recovering from the clear-cutting practices of early logging crews and from damage inflicted by the 1938 hurricane.

The hiking boom of the late 1960s and early 1970s was also beginning to have an impact on the WMNF and its many trails. "I can remember many maintenance trips up on the Jewell Trail to Mount Washington when we wouldn't meet a single hiker, not even in the summer," said Derosia. "The last time I was up there, though, there was a constant stream of hikers heading up the mountain. That was quite a change from the old days."

Even forest management practices had begun changing by then, especially the way timber harvests were carried out. "We never used to clear-cut anything. Every sale was select cut. This clear-cutting bothers me now and has for years."

Though he never planned on a career in forestry, Derosia said he has no regrets about his choice. "It was good, hard work, but very enjoyable. I made the right decision to stay with it."

Opposite, top: Louis Derosia (right) and a fellow Forest Service employee take a midday winter lunch break in the White Mountain National Forest. *Derosia family archives.*

Opposite, bottom: Louis Derosia is recognized for his thirty years of work with the Forest Service in this undated image. *Derosia family archives.*

Chapter 11

Schuyler Dodge and the Mountain View House

Just two weeks before his unexpected death on November 23, 1999, I had the privilege of sitting down and interviewing longtime Mountain View House owner Frank Schuyler Dodge Jr. at his modest country home in Bethlehem, New Hampshire. During this afternoon-long visit, the amiable Dodge reminisced about his years in the hotel industry and his longtime family ties to the landmark Whitefield hotel. In the years since my sit-down talk with Dodge, the hilltop structure has been reborn, and following a multi-year $20 million renovation project that ultimately led to the reopening of the Mountain View in 2002, the hotel is once again a thriving entity and a true jewel of the North Country. The following piece first appeared in print in the December 29, 1999 edition of The Courier *newspaper of Littleton. With the exception of a few minor changes, it appears here in its original form.*

As a fourth-generation owner and operator of the landmark Mountain View House in Whitefield, Frank Schuyler Dodge Jr. knew how to attract guests to the scenic hilltop resort property and also how to get them to come back year after year. "You did things right, and you did them with style," said the seventy-one-year-old Dodge, who today lives in Bethlehem on a small horse farm.

Schuyler, as he is usually called, was the last member of the Dodge clan to operate the once-fashionable resort known for its immaculate grounds, unsurpassed hospitality and million-dollar view of the White Mountains. Dating back to 1866, when his great-grandparents, William E. and Mary Jane Dodge, built a small addition onto their farmhouse to take in boarders,

the Mountain View attracted summer guests for more than 120 seasons, and for all but the last seven summers of its operation, the Dodge family ran the show.

A visit to the Mountain View property now, some thirteen years after the hotel closed following its 122nd consecutive season of operation, is difficult to digest, even though there is hope that the property's new owner will someday soon refurbish and reopen the grand hotel. A dozen years of neglect have taken their toll on the once-majestic four-story structure. Yet a scant twenty-five years ago, under Schuyler Dodge's direction, the hotel was still a vibrant, profitable entity.

Schuyler Dodge stands in front of the Mountain View House in Whitefield. *Courtesy of Barbara Dodge.*

Schuyler Dodge literally grew up with the hotel and spent every summer of his youth at the Dodge-owned resort. When he was born in 1928, to Frank S. and Mary Bowden Dodge, his father already had nine years of managing the hotel under his belt. His dad would continue as manager until his sudden death by heart attack at the height of the 1948 summer season. For the next five seasons, his mother, the widowed Mary Dodge, ran the hotel. Her kids finally of age, she was more than happy to hand over management responsibilities to her two sons, Schuyler and John, at the start of the 1954 season.

In its heyday, recalled Schuyler in a recent sit-down interview, the Mountain View House was among the most elite in New England, attracting an admittedly wealthy and "snobbish" clientele. "I helped create the snob atmosphere at the hotel. But that was the crowd that we wanted to cater to." Dodge said the hotel drew from a markedly different clientele than the larger and perhaps better-known Mount Washington Hotel at nearby Bretton Woods. "Our reputation was that because we weren't as big as the Mount Washington, we could pay our guests a little more personal attention. That's what they preferred…being waited on hand and foot."

The two-hundred-room Mountain View House in its glory years. *Author's collection.*

Dodge family members and their spouses. *Front, left to right*: Mary Dodge Bailey, Virginia Dodge and Lydia Sweeney Dodge. *Back, left to right*: Dr. James Bailey, Schuyler Dodge and John Dodge. *Author's collection.*

Celebrating the Region's Historic Past

For every guest at the hotel—and there were quite a few in Dodge's time, as the hotel had about two hundred guest rooms—there was usually one employee on the payroll. As much as anything else, it was the hotel staff that made the Mountain View the success story it was for the bulk of the twentieth century. "It was the employees' hotel as much as it was mine," said Dodge. "We had so many dedicated people—some of whom worked at the place for fifty years or more. They really loved the place and cared about it."

In his more than twenty-five years as manager, first as co-manager (1954–66) and then as sole manager (1967–79), Dodge and his staff bent over backward to meet the requests and whims of the hotel's well-heeled guests, many of whom stayed on the property from the start of July through Labor Day, and some, summer after summer. "We did our best to make the guests feel as though the property was as much theirs as ours," said Dodge. To help foster that atmosphere, Dodge recalled one year when, during the off-season, he allowed a group of returning summer-long guests to choose the patterns for the new wallpaper that was to be hung in their rooms. "We gave about twenty-five guests three choices each to pick from," recalled Dodge. "It was a bit of a nightmare for us, but it made the biggest impression on our guests."

In those days, many of the hotel's rooms were referred to not by their room numbers but by the people who stayed in them. "There was definitely a sense of ownership created at the hotel."

Naturally, there were times when pushy guests rubbed management and employees the wrong way. In those instances, Dodge and his workers often had to bite their tongues rather than lash back at their guests. On occasion, though, these types of guests were put in their places, sometimes without them even knowing it.

"We had one guest, a well-known New York stock investor, who one year booked a suite for the entire summer. He wanted three bedrooms—one for himself, one for his valet and one where he could store his six steamer trunks. He also had to have a living room area, where he insisted he'd eat every meal, rather than eat in the dining room," recalled Dodge. "Since he refused to eat off the hotel menu, every day he'd call the chef and tell him what he wanted for dinner that night. It would be specially prepared for him and brought to his room. One day, he called the executive chef and requested 'pheasant under glass.' When the chef said that wasn't something his kitchen staff normally prepared, the guest responded by saying, 'When I'm in New York, I stay at the Waldorf, and when I request pheasant, I always get it.'

To that, our chef said he'd get what the man wanted. After hanging up the phone, he sent one of his men down to the hotel barn and told him to shoot two pigeons and bring them back to the kitchen. He did as he was told, and the chef proceeded to cook and braise the pigeons and then had the meal sent up to the guest's room for dinner. The next day, the guest called the chef and told him, 'I've never had pheasant so wonderful.' He never did find out he'd been served pigeon."

Dodge also recalled the time when the wife of millionaire businessman John J. Astor called to book a room at the Mountain View. Originally, she was told to arrive by plane at the Whitefield Airport, where the hotel had promised to send someone to meet her. Poor weather in and around the mountains forced her plane to land instead in Barre, Vermont, an hour and a half away. Mrs. Astor arranged for a taxi to drive her from Barre to Whitefield, but en route, the cab driver, unfamiliar with the area, failed to locate the hotel access road in the darkness of night, and he drove around for quite some time before finally finding the Mountain View.

Dodge, awaiting the arrival of the then-overdue Astor, saw the taxi pull up to the front door and upon greeting his newly arrived guest was subjected to a lengthy diatribe in which Mrs. Astor criticized the hotel and its management for failing to have the access road properly signed. "How do you expect guests to find this place?" she asked.

The manager's response was succinct and to the point. "Madam," replied Dodge, "I don't cater to the traveling public. My guests know where we are." The next morning, Mrs. Astor called and apologized to Dodge for her behavior the previous evening.

The hotel that Dodge knew as manager was not the same hotel that had ushered in the new millennium back in 1900. Back then, it was still a relatively small country inn, but just on the verge of becoming a grand resort in its own right under the management of Schuyler's grandparents, Van Herbert Dodge and Alice (Stebbins) Dodge. Though Van Dodge was officially the manager of the Mountain View from 1884 to 1919, it was no secret that his wife, Alice, was the true manager. "Grandfather was not really a hotel man…but his wife was an awfully smart woman, and she's the one who saw to it that things got done around the place," said Schuyler. Van Dodge, he explained, had other business interests, including serving as president of the Whitefield Bank and Trust Company. During a run on the bank on October 1929, when Wall Street suffered its infamous crash, it was Van Dodge who singlehandedly saved the Whitefield bank from going out of business. Using cash receipts from the hotel, which he faithfully kept hidden

An aerial view of the Mountain View House complex. *Author's collection.*

under his bed throughout the course of the summer season, he prevented the bank from giving out all its money, declaring at the time, "No one is going to close my bank."

Under Frank S. Dodge, Schuyler's dad, the Mountain View continued to grow in size until the late 1920s, when the last major addition to the structure was added, that being an expanded east wing. It was during his tenure as manager that Frank Dodge married Mary Bowden, who he met while she was a guest at the hotel. Like the other Dodge women before her, she became intimately involved in the operation of the resort once she married into the Dodge family. This involvement paid off in 1948 when her husband died unexpectedly and she was forced to run the entire property.

"Mother knew someone had to run the place...and even though she'd never really worked there before (because she didn't have to)...she did very well as manager," remembered Schuyler. When the time came six years later to hand the reins over to her sons, Mary Dodge made it clear to the boys who the boss still was. "She said, 'You may be co-managers, but I'm chairman of the board.'"

The spectacular view from the front of the hotel and what was long known as Begonia Terrace. *Author's collection.*

Among the major changes Schuyler Dodge saw take place at the Mountain View during his long tenure as manager was the emergence of the convention business as a staple of the late spring and post–Labor Day seasons and the gradual loss of the summer-long hotel guest. "We went aggressively after the convention business and pretty much had a lock on it for a time. The conventions were vital to the spring and fall operation because we were dealing with 30 to 40 percent occupancy rates rather than the 90 to 95 percent rates of the summer season. We needed to fill the hotel during those time periods, and the conventions did just that."

Looking back at the years leading up to his decision in 1979 to sell the Mountain View to Robert and Ann Hiltz, Schuyler Dodge said rising business costs and shrinking profit margins made the decision an easy one. "I looked at the numbers on a graph that my accountant had drawn up, and I could see the expense line was catching up to the income line. I told him, 'I don't want to be here when the two lines meet.'"

Dodge said being so intimately involved with the family-owned hotel for so many years was an experience he will always cherish. "For an old place like that, it was a wonderful business."

Bibliography

Books

Baird, Iris W., and Chris Haartz. *A Field Guide to New Hampshire Firetowers*. Lancaster, NH: New Hampshire Department of Resources and Economic Development, Forests and Lands, 1982.

Bean, Grace H. *The Town at the End of the Road: A History of Waterville Valley*. Canaan, NH: Phoenix Publishing, 1983.

Belcher, C. Francis. *Logging Railroads of the White Mountains*. Boston: Appalachian Mountain Club, 1980.

Bent, Allen H. A *Bibliography of the White Mountains*. Boston: Appalachian Mountain Club, 1911.

Brown, William Robinson. *Our Forest Heritage: A History of Forestry and Recreation in New Hampshire*. Concord, NH: New Hampshire Historical Society, 1958.

Bibliography

Burt, F. Allen. *Story of Mount Washington*. Hanover, NH: Dartmouth Publications, 1960.

Colby, John, ed. *Littleton: Crossroads of Northern New Hampshire*. Canaan, NH: Phoenix Publishing, 1984.

Crawford, Lucy. *The History of the White Mountains: From the First Settlement of Upper Coos and Pequaket*. Portland, ME: B. Thurston & Company, 1886.

Dickerman, Mike. *Lincoln and Woodstock, New Hampshire*. Littleton, NH: Bondcliff Books, 2005.

Draves, David. D. *Builder of Men: Life in CCC Camps in New Hampshire*. Portsmouth, NH: Peter Randall Publishing, 1992.

Eastman, Samuel C. *The White Mountain Guide Book*. 7th ed. Concord, NH: Edson C. Eastman, 1867.

Goodrich, A.L. *The Waterville Valley*. 2nd ed. Waterville Valley, NH: 1904

Gove, Bill. *J.E. Henry's Logging Railroads*. 2nd ed. Littleton, NH: Bondcliff Books, 2012.

———. *Logging Railroads Along the Pemigewasset River*. Littleton, NH: Bondcliff Books, 2006.

———. *Logging Railroads of New Hampshire's North Country*. Littleton, NH: Bondcliff Books, 2010.

———. *Logging Railroads of the Saco River Valley*. Littleton, NH: Bondcliff Books, 2001.

Heard, Patricia, and Shirley Elder Lyons, eds. *Sandwich, New Hampshire: 1763–1990*. Portsmouth, NH: Peter E. Randall, 1995.

Hooke, David O. *Reaching That Peak: 75 Years of the Dartmouth Outing Club*. Canaan, NH: Phoenix Publishing, 1987.

Hounsell, Janet McAllister, and Ruth Burnham Davis Horne. *Conway, New Hampshire, 1976–1997*. Portsmouth, NH: Peter E. Randall, 1998.

Judge, Josh. *Extreme New England Weather*. Greenfield, NH: SciArt Media, 2010.

Kilbourne, Frederick W. *Chronicles of the White Mountains*. Boston: Houghton Mifflin Company, 1916.

King, Thomas Starr. *The White Hills: Their Legends, Landscape, and Poetry*. Boston: Isaac N. Andrews, 1859.

Morse, William S. *A Mix of Years*. Warren, NH: Moose Country Press, 1998.

O'Kane, Walter Collins. *Trails and Summits of the White Mountains*. Cambridge, MA: Riverside Press, 1925.

Pickering, William H. *Guide to the Mount Washington Range*. Boston: A. Williams and Company, 1882.

Pinette, Richard E. *Northwoods Echoes*. Colebrook, NH: Self-published, 1986.

Putnam, William Lowell. *The Worst Weather on Earth*. Gorham, NH: Mount Washington Observatory, 1991.

Ramsey, Floyd W. *Shrouded Memories: True Stories from the White Mountains of New Hampshire*. Reprint. Littleton, NH: Bondcliff Books, 2002.

Smith, Steven D. *Ponds and Lakes of the White Mountains*. 2nd ed. Woodstock, VT: Backcountry Publications, 1998.

Smith, Steven D., and Mike Dickerman. *White Mountain Guide*. 29th ed. Boston: Appalachian Mountain Club Books, 2012.

———. *The 4000-Footers of the White Mountains*. 2nd ed. Littleton, NH: Bondcliff Books, 2008.

Sweetser, Moses F. *The White Mountains: A Handbook for Travellers*. Cambridge, MA: Riverside Press, 1890.

Bibliography

Tolles, Bryant F., Jr. *The Grand Resort Hotels of the White Mountains.* Boston: David R. Godine, 1998.

Washburn, Henry Bradford, Jr. *Trails and Peaks of the Presidential Range of the White Mountains.* Worcester, MA, 1926.

Waterman, Guy. *An Outline of Trail Development in the White Mountains 1840-1980.* Randolph, NH: Randolph Mountain Club, 2005.

Watson, Benjamin, ed. *New England's Disastrous Weather.* Emmaus, PA: Yankee Books, 1990.

Wight, D.B. *The Androscoggin River Valley: Gateway to the White Mountains.* Rutland, VT: Charles E. Tuttle Company, 1967.

———. *The Wild River Wilderness.* Littleton, NH: Courier Printing Co., 1971.

Wroth, Katharine, ed. *White Mountain Guide: A Centennial Retrospective.* Boston: Appalachian Mountain Club, 2007.

Periodicals and Journals

Appalachia
Among the Clouds
Bristol Enterprise
Coos County Democrat
The Dartmouth
Dartmouth Medical Magazine
The Littleton Courier
Manchester Union-Leader
Mount Washington Observatory Bulletin
White Mountain Echo and Tourist's Register

About the Author

Mike Dickerman is a longtime northern New Hampshire resident who was lured to the White Mountains region by its many foot trails and magnificent summits and lush valleys. After more than a decade of reporting on area events for the *Littleton Courier* newspaper, he started his own publishing company (Bondcliff Books) in 1996 and regularly writes, publishes and distributes books related to New Hampshire's North Country and White Mountains. For more than twenty-five years, his popular hiking column, "The Beaten Path," has appeared regularly in newspapers across the Granite State. He has authored or edited numerous books, including *White Mountains Hiking History: Trailblazers of the Granite*, *The 4,000-Footers of the White Mountains*, *Along the Beaten Path*, *Mount Washington: Narratives and Perspectives* and *Lincoln and Woodstock, New Hampshire*. He was also co-editor of the award-winning anthology *Beyond the Notches: Stories of Place in New Hampshire's North Country* and the twenty-ninth edition of the *AMC White Mountain Guide*. Mike lives in Littleton, New Hampshire, with his wife, Jeanne.

Visit us at
www.historypress.net

This title is also available as an e-book